Polly Borland
Australians

Published to accompany the exhibition *Polly Borland: Australians*
held at the National Portrait Gallery, London from 25 May to 17 September 2000
and at the National Portrait Gallery, Canberra from 2 March to 13 May 2001

Published in Great Britain by National Portrait Gallery Publications,
National Portrait Gallery, St Martin's Place, London WC2H OHE
in association with
National Portrait Gallery, Old Parliament House,
King George Terrace, Parkes, Canberra, ACT 2600

ISBN 1 85514 282 1

A catalogue record of this book is available from the British Library.

Curator: Terence Pepper
Senior Editor: Anjali Bulley
Design: Miles Murray Sorrell (Fuel)

Printed by Westway Offset Limited, England

For a complete catalogue of our publications please write to the address above
or visit our website at www.npg.org.uk

Front cover: Lloyd Newson; Dancer, Choreographer

Sponsored by ROBERT WALTERS

The organisers of *Polly Borland: Australians* would like to thank Robert Walters,
the global recruitment consultancy, for their generous sponsorship; Tapestry for the
photographic processing and exhibition prints; and AGFA for the supply of film stock.

Polly Borland
Australians

Foreword by Charles Saumarez Smith
and Andrew Sayers

Fifty-odd Australians by Peter Conrad

Dancing by Nick Cave

Interviews by Virginia Ginnane

National Portrait Gallery, London
in association with
National Portrait Gallery, Canberra

Foreword

In September 1999 I visited the newly established National Portrait Gallery in Canberra and was able to see their magnificent exhibition, *Glossy: Faces Magazines Now*, which explored the connections between fame and the industry of the glossy magazine. The star of the show was Polly Borland with her hard-edged images, including Monica Lewinsky looking lost in the world of international celebrity.

By then, the National Portrait Gallery in London had already committed itself to a major exhibition project by Polly Borland, a previous winner of the *John Kobal Photographic Award*. It has involved her documenting the role of Australians in Britain in order to demonstrate the range of their involvement in all aspects of British cultural, political and intellectual life. Some of her sitters are well known as Australians, including Germaine Greer and Clive James. But I did not know, for example, that the Vice-Chancellor of Cambridge University is an Australian.

All those people who have been involved the project are listed in the acknowledgements, but the principal person who deserves to be thanked is Polly herself. She is the person who has ensured such a wide range of sitters and, indeed, has undertaken the project at considerable cost to herself. We are also exceptionally grateful to Robert Walters, the global recruitment agency, for sponsoring the exhibition during its showing in London.

This exhibition is the first fully collaborative venture between the newest of the world's national portrait galleries and the oldest. Whilst our new institution is unable to match the long and illustrious life of the National Portrait Gallery in London, we hope that we have begun to inspire the affection which our sister gallery inspires in its community. Furthermore we hope that the vigorous and exciting mix of the old and the new – so conspicuous a feature of London's programe – will characterise the activities of Canberra's National Portrait Gallery.

This is a particularly fitting exhibition with which to launch what I hope will be the start of a series of collaborative ventures. At a fundamental level, the exhibition celebrates the contribution made by one culture to another. Yet the exhibition also celebrates individuality and, like all exhibitions in which portraiture is the medium, it allows us to see how opportunity, ideas, accident, luck and brains are, in varying measures, present in lives of achievement.

Our collaboration in this project is part of our contribution to Australia's Centenary of Federation. The Centenary allows us to look at the precursors of the current generation of Australians in Britain. One hundred years ago there were many Australians who were contributing significantly to British life and there have been many more over the ensuing century; some of whom are celebrated in Polly Borland's photographs. While a surprising number have been in the field of the arts, they have contributed in all fields of endeavour, from Nellie Melba in opera to Lord Florey in medical research. The extent and nature of this contribution can hardly be summed up or neatly characterised, yet there are a large number of life stories which have more than their fair share of those apparently Australian characteristics of fierce individualism, doggedness, contempt for received wisdom and larrikin humour.

It is a great delight to me that this exhibition celebrates not only the contemporary end of these ongoing Australian injections into British life, but is the work of an artist we greatly admire. Polly Borland's work was included in an exhibition mounted in our gallery in mid-1999 entitled *Glossy: Faces Magazines Now*. In that exhibition a room was devoted to her portraits and in it, the distinctiveness of her approach to colour and materials, and the originality of her photographic personality were quite overwhelming. It was clear in that exhibition – as it is in the collection of images in this current exhibition and publication – that many of her photographs are destined to become definitive images of these contemporary icons.

Charles Saumarez Smith
Director
National Portrait Gallery, London

Andrew Sayers
Director
National Portrait Gallery, Canberra

Polly came around to the place where I'm living saying she wanted to take some photos of me dancing. I put on my obligatory suit; stuck Al Green on the player and off we went. I know why Polly wants me dancing. She wants me to relax. She knows that the camera gives me the creeps. What she is also aware of is that no camera gives me the creeps quite as much as one with Polly Borland behind it. When we confront the camera, we do so in order to show the world the way in which we wish to be perceived. Polly has that unique ability to grab the moment between poses when we have disarranged our faces, our postures and regained our humanity. We are rarely human in front of the camera. No one really wants to be reminded of how he or she actually is. I dance on. Polly snaps away. 'You can stop now,' says Polly, 'I think I've got it', but I have been photographed many, many times by Polly, we are good friends, despite the fact that she is a photographer, and I know that what she is saying is not necessarily true. She is a predator and she is waiting. Polly says she wants to take a photograph of me and my wife. Susie sits relaxed in the knowledge that even the cruellest camera cannot disassemble her incandescent beauty. I sit glumly by her side. 'Finished!' says Polly and I whack on a T-shirt my wife has given me for my birthday. 'Hold still', says Polly, then SNAP! SNAP! SNAP! SNAP! And there you have it. Polly has stolen from me that moment when I have forgotten who I am and all that I wish to be. Magically she has rendered herself absent and I am alone.

Nick Cave

The archetypal Australian portrait is of a man without a face – Max Dupain's *Sunbaker*, photographed on a Sydney beach in 1937. His head, cradled in his arms, slumps in the sand, while his exposed shoulders sizzle. His lack of identity makes him monolithic. The outline of his upper body, undulating above a desert, exactly duplicates the profile of Ayers Rock, the continent's omphalos. He has a fortuitous walk-on part in Polly Borland's collection: as a treasured, nostalgic totem, a reproduction of Dupain's photograph hangs among a collection of ill-aligned snapshots on the wall of John Pilger's home, just to the left of his shoulder.

In a way, it's appropriate that Dupain's subject should have lowered his face towards the hot sand. Traditionally, artists wanting to portray Australia have concentrated on scenery, not the people who wandered or struggled through it. To begin with, the background necessarily dwarfed or effaced the foreground in which brave, isolated settlers grappled with a nature apparently not created by the same god who invented the northern hemisphere. An early photographer such as Harold Cazneaux, who worked in Sydney between the world wars, characterised his fellow-countrymen by allegorising the trees which outnumbered them. Cazneaux's *Spirit of Endurance*, a tribute to the stoicism required by the frontier, is a eucalyptus managing to exist for generations in a land with too little water; his *Veterans* are also trees, not soldiers.

What mattered, during that first long battle with nature, was bodies; minds were not yet called for. David Moore photographed sunbathers, seen from behind, at the Sydney Cricket Ground in 1963. Faces, as on Dupain's beach, are overlooked, dispensable in this democracy of bronzed brawn. When Dupain turned from landscapes to people, he mostly photographed groups: crabby housewives queuing for rationed meat in 1946, or builders' labourers swigging tea from their billy cans.

Jack Cato, the portraitist whose career was boosted by the opera singer Nellie Melba, worried about extending the photographic franchise beyond high society. Did ordinary Australians deserve to have their portraits made? During the 1920s in Hobart he experimentally mounted a show of what he called 'odd characters' – all the old newsboys, billposters, pedlars, old fisherman, morons and identities that everyone knew. He identified these gnarled grotesques by their nicknames – Silly Snorky, Sandstone Jimmy, Dick the preacher, Cackles the dwarf, Loony Fred, Whiskers White. His affluent clientele took fright. Their faces were familiar, but no-one had ever considered these street people to be 'picturesque and capable of being made into salon pictures'. As Cato's misgivings indicate, the individual arrived belatedly in a society that valued uniformity. In 1908 Mrs Aeneas Gunn, in her outback memoir *We of the Never-Never*, classified the 'bush-folk' in the same way. Her husband is The Boss, she is The

Little Missus. The Man-in-Charge and The Quiet Stockman behave exactly as their names dictate. On the periphery lurk 'a few black "boys"', and 'a dog or two'.

Initially, the price of individuality was relegation to the status of a crank. This is the subject of Patrick White's novels, which narrate the psychological history of the new country. After *The Tree of Man*, Australia's pastoral peace is disturbed by a fanatical explorer, a crazed aunt, a consortium of Blakean mystics, and an artist who vivisects the drab world of appearances. Appropriately, White himself in his last decades became the subject of a serial portrait by the photographer William Yang. Though his face was an Australian template – long, lean and eroded, oddly like the old-time film actor Chips Rafferty, who specialised in grizzled bush-whackers – White's expressions, as recorded by Yang, hardly belong in the bright, bland, matey Australia which thought of itself as 'the lucky country'. He is pensive, mischievous, wicked, crabby or downright furious, towards the end spectral, but never well-adjusted.

In *Eucalyptus*, a novel about Australia's unequal balance between nature and culture, Murray Bail rather grudgingly concedes that 'some description of landscape is necessary'. But eventually, he predicts, the trees will recede into a scenic background, 'in front of which all cultures go through their motions'. That change, of course, has already happened; Polly Borland's expatriated Australians are a plantation of uprooted trees, flourishing in an inimical climate. Even the single Aboriginal on view, Herb Wharton, has strayed far away from his traditional stamping-ground. Walking down Oxford Street in London, he looks marginally less exotic than the man in the foreground with the Hawaiian shirt and the greasy burger, who seems to believe that Polly is photographing him. To my eye, Leo McKern is more tribal than Wharton, cackling arcanely behind a second skin of war paint. A Tasmanian tiger appears in another photograph, but only as a prop – stiff, stuffed and uncomfortably poised on the lap of Sir Robert May. The Australian landscape, I think, makes a single appearance in these photographs, and that is on the dome of Clive James's head. His skin resembles the Nullarbor Plain seen from thirty thousand feet, and the residual fringe of hair on the ridge is like the scratchy, scrawny, irregular bush painted by Fred Williams.

Otherwise, these are Australians who have freed themselves from the need to personify the nation. Only one of them, Sir Les Patterson, flies the flag (and he, fortunately, does not exist). Otherwise Polly's subjects take pride, unlike Jack Cato's social outcasts, in being 'odd characters'. Peter Tatchell advertises his assault on public order and official hypocrisy, and Nick Cave allows his T-shirt to voice his disdain for propriety. Rolf Harris exhibits an extra leg. More than an expatriate, John Hillcoat looks like an extra-terrestrial. The people in this group, who have been assimilated into England and wear the Establishment's uniforms,

still conduct their own sly subversion hinting that this ancient, sclerotic society is nothing more than a fancy-dress party. A dead sheep has landed on Geoffrey Robertson's head, and Sir Charles Mackerras, dressed to conduct, acknowledges the absurdity of his get-up by wearily collapsing onto that gruesomely patterned bedspread. Yvonne Kenny, photographed backstage during a rehearsal of *Der Rosenkavalier*, is all set to mutate into a Viennese aristocrat during the last days of the Austro-Hungarian empire – except for those tennis shoes and the sunglasses, which suggest that she might happily exchange a night at the opera for an afternoon at Bondi. And is Geoffrey Crawford, camped in a Buckingham Palace corridor, pretending to be the punctilious Niles from *Frasier*?

All of us in this exhibition, I suspect, resemble the idiosyncratic beings studied by Polly in her previous project. She has spent years exploring the secret subculture of people who wilfully recover childhood in bloated middle age with the help of outsize diapers, bibs as big as tablecloths, and lashings of talc applied to hairy chests. The sniffy medical term for these gentle, blubbery monsters is infantilists, but 'Snuggles' the beer-gutted truck driver in nappies or 'Julieanne' the grey-haired storeman, who happily splatters a room with strained apple in one of Polly's photographs, have a cosier name for themselves. They are known as Babies, differentiated from the real thing by an honorific capital letter. These would-be children are their own parents. Though none of the Babies are Australian, expatriates too are voluntary orphans, self-exiled from Freud's lost paradise of childhood. Australia is a family to which we are not sure that we belong. What Polly admires about the Babies is their capacity for self-invention, and the same capacity is shared by her overseas compatriots. Cate Blanchett, ready to turn herself into a British monarch or an American housewife or whatever else is required, is in permanent flight – like all actors – from the self she was born with, and the home that told her who she was supposed to be. An artist, as Ron Mueck's triumphant smirk announces, is someone who can impenitently go on playing childhood games in adult life, making messes like those of 'Julieanne'.

A portrait session with Polly is therefore a little like an unsupervised play-date. As a co-conspirator, she appeals to you to flaunt grown-up rules. At the very least, she will persuade you to clamber onto the furniture, like Bill Muirhead or Bob Godfrey. If you are really game, you might let her accompany you into the shower, as Lloyd Newson did. Even a staid businessman like Leon Davis has somehow been cajoled to sit sideways on a chair which is far too small for him. Probably, keen to see what she can get away with, she will suggest that you undress: Kylie Minogue – a creation of the camera, after all – happily obliged. Polly likes to lead her subjects to the bedroom, though not because photography is seduction or rape by other means. The bedroom is a place where façades relax a little. Pat Cash consented to lie down, although athletes

(unless they are swimmers) don't usually care to be seen in a horizontal position. Samantha Bond and her models seem prepared for a pyjama party.

With hindsight, now that I have seen all fifty-odd of these photographs, I regret being the boy who sulked in the corner of the playground and wouldn't join in the game. Polly, minutes after arriving at my house to photograph me, tried to get me to go to bed – preferably cuddling a menagerie of toy dogs which, in company with a polyester Tasmanian devil (guaranteed non-allergenic, and made in Korea) guard my stairs. When this ploy failed, she wondered if I might not nestle up to a three-foot-tall model of Superman, which she found on one of my landings. I refused that too, on the grounds that Superman is American. I knew, you see, about Polly's fondness for the work of Diane Arbus, and did not want to be enrolled in a freak show. She had to settle for a glowering head, and a face which defies the casual Australian creed of 'No worries'.

I needn't have been so mistrustful. Despite Susan Sontag's strident declaration, to be photographed is not necessarily an act of violation. Germaine Greer – stripped down to her earrings, deprived of the crossness and the bifocal gaze inside which she sometimes armours herself – never looked better than she does here. Polly has a way of seeking out fragility, and sympathising with it. As she said to me about the Babies, 'These are people in a lonely, desperate place – and I've been there with them'. No wonder Polly appears as a nurse in a photograph in an operating theatre – though photographers remain coolly neutral, and can remain safely invisible behind the camera: hence the surgical mask she wears in her own portrait. Still, under the mask she seems to be smiling. Her view of people is amused but tender. Her portrait of Carmen Callil, for instance, is almost a votive image. The shelves stacked with books Carmen published (and in many cases inspired) constitute a domestic altar; surmounted by a halo of light bulbs, she nurses her adored terrier Deborah. Her eyes close on a private happiness. This is not so much Madonna and child as Virago and dog.

The photograph is funny, beautiful, and a bit sad. A dog - like Michael Blakemore's cat or Sarah Harmarnee's horse, but unlike Sir Robert May's tiger - is a substitute, replacing some other source of affection which is missing, or which we perhaps abandoned when we grew up or when we left home. All of us in this exhibition, including the photographer, are runaway children. But the news is finally reaching the most stubbornly prodigal of us: it is safe to go home. And we have more right to be there than the man Dupain identified as the sunbaker. He was, as it happens, a visitor from England, burying his head in the sand to shield his eyes from all that antipodean brilliance.

Peter Conrad

Plates

Barry Humphries AO
Comedian, Writer

Born in Melbourne, 1934. After studying law at Melbourne University,
Humphries joined the Melbourne Theatre Company and in 1955 he
created Mrs Edna Everage, a Moonee Ponds mother and housewife.
From the late 1950s to date he has regularly performed in one-man
plays of his own devising in many parts of the world, notably Australia,
Britain, Europe and in the United States, where he is currently starring
on Broadway in his most successful offering to date. *A Night with
Dame Edna* (1979) won the Society of West End Theatres Award and
his television special *A Night on Mount Edna* (1991) secured him the
Golden Rose of Montreux. Humphries is the author of many books
and plays, and his autobiography *More Please* won the J.R. Ackerley
prize for biography in 1993. He is married with four children and his
hobbies are landscape painting and Portuguese studies.

The reason I first left Australia was because I couldn't stand it any longer. The
reason I will always love Australia is because, unlike most things in life, it never
changes.

I always know when I am approaching Australia by a distant thumping sound:
millions of my countrymen patting themselves on the back.

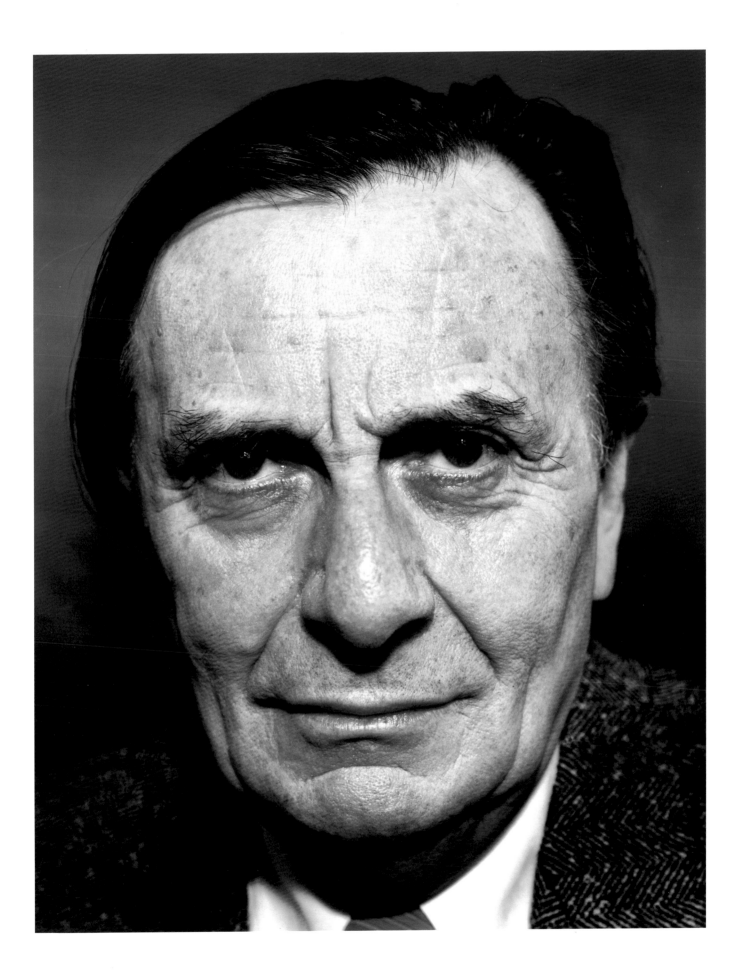

Marc Newson
Designer

Born in Sydney, 1963. After graduating in Jewellery and Sculpture
at the Sydney College of the Arts in 1984, Marc Newson was awarded
a grant from the Australian Crafts Council to stage an exhibition at
the Roslyn Oxley 9 Gallery in Sydney. He moved to Tokyo in 1987 for
the manufacture of his furniture designs and in 1991 set up a studio
in Paris, where he won commissions for lighting, furniture and his
Ikepod watches. He has also exhibited extensively, creating the
Bucky, a sculptural installation for the Fondation Cartier in Paris in
1995. Newson moved to London in 1997, where he now designs
glassware and home accessories for mass-manufacture. Current
projects include the design of the interior and exterior of a Falcon
900B Business Jet, a concept car for Ford and a bicycle for Biomega.
Many international museums have acquired Newson's designs for
their permanent collections.

Which characteristics identify you as an Australian?
My accent. Being depressed in winter [*laughs*]. Being Australian doesn't figure
very seriously in what I'm doing.
What is it about the UK that has allowed your work to flourish?
I moved here from Paris... I found it impossible to further my career there,
because of the complicated bureaucracy. In England it's just ten times easier,
setting up companies, all that really boring mundane stuff. I find it much more
like being in Sydney, apart from the climate, [but] I'm not here because I'm
looking for a surrogate Sydney. The UK is very racially tolerant, very cosmo-
politan; its pop and youth culture play an important part in what I do. I'm influ-
enced by contemporary culture, design, cinema – in that sense, it's a very
interesting place to be. Also geographically, it's central for clients. London is
just so big and they seem to have come to grips with their colonial history, their
colonial past, unlike countries such as France.
What did the referendum represent?
It represented a coming of age. I really feel that [the opportunity to vote for a
republic] was an incredibly symbolic thing. Especially now, what a perfect time
to do it. Why does Australia have to tow the line? [*outrage*] It smacks of the
things I dislike about Australia. The cultural cringe, the inferiority, which I just
can't deal with at all. I just wish they could get a grip and assume their identity.
There is everything there you need for it to be a completely socially and polit-
ically exciting place, and therefore culturally. I can't help but see the decision
[the referendum result] as being a completely regressive step. Because God
knows when they're going to do it again.
How was the shoot with Polly?
She just took my photo, pretty fast which was good. It was a mish-mash of her

ideas and mine. I like the relaxed approach to the whole thing and not want-
ing it to be a fashion spread. It was pretty Australian. Polly asked me to do
things, and I just said 'No' and that was OK. Like wanting me to take my shirt
off and I'm, like, 'Sorry?' [*laughs*].

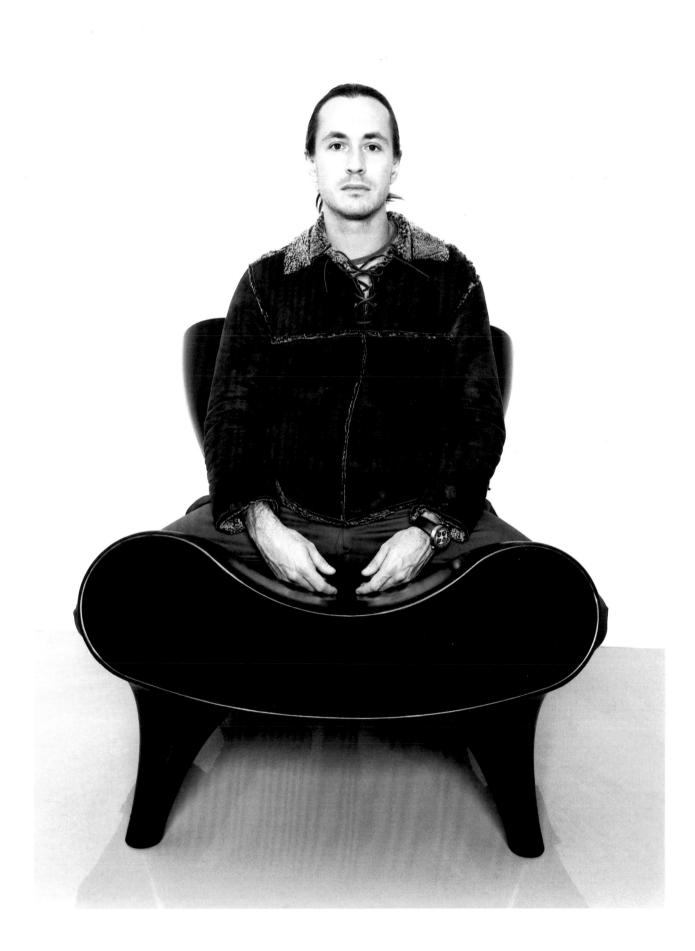

Ron Mueck
Sculptor

Born in Melbourne, 1958. Ron Mueck worked in children's television from 1979-83 (*Shirl's Neighbourhood*). In 1983 he moved to New York, working with Jim Henson on film and television projects such as *Labyrinth* and *The Story Teller*. Starting his own company in 1987, he created animatronics and models for the advertising industry in Europe. Mueck's first solo exhibition as a sculptor was held at the Anthony d'Offay Gallery in 1998. His group shows include *Spellbound* at the Hayward Gallery, London (1996); *Sensation: Works of Art from the Saatchi Collection* at the Royal Academy of Arts, London (1997); *Unsichere Grenzen, Kunsthalle zu Kiel*, Kiel (1999) and *The Mind Zone, Millennium Dome*, London (1999).

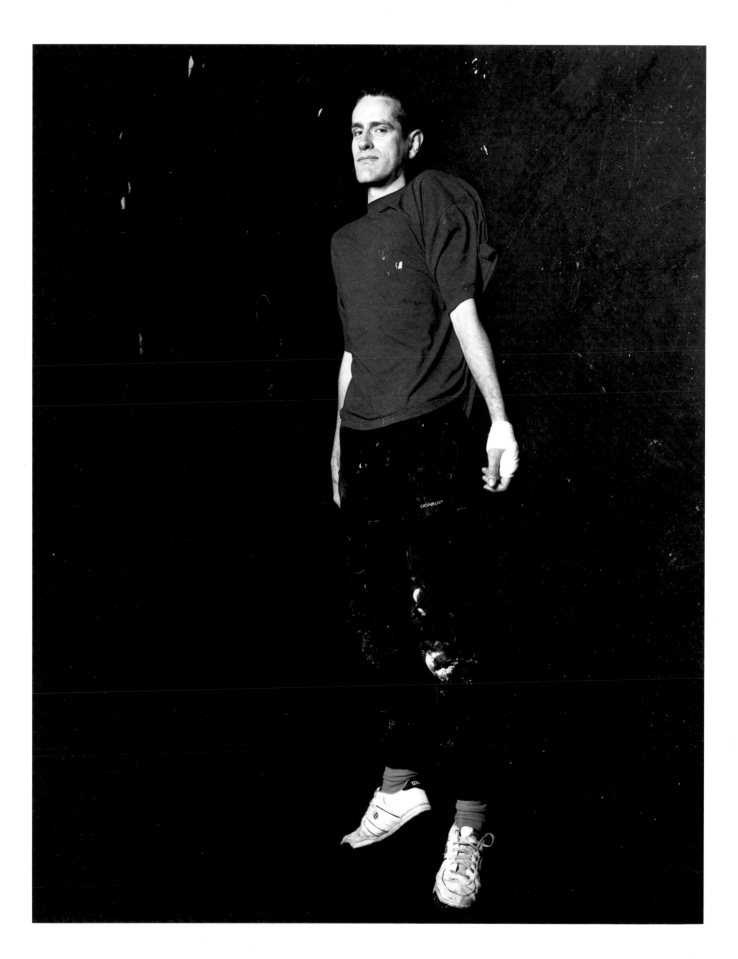

Bruce Gyngell
Television Executive

Born in Melbourne, 1929. Bruce Gyngell was the first person to appear on Australian television when it began transmission on 16 September 1956. He became Managing Director of the Nine Network and was a major influence on the development of the television industry in Australia. His appointments as Founding Chairman of the Australian Broadcasting Tribunal (1977-80), and as the first Chief Executive of SBS (1980-82), reflect his dedication to raising awareness of the social responsibility of the industry. He first moved to the UK in 1971 and became Managing Director of the commercial television station ATV. He pioneered breakfast television broadcasting as Managing Director of TV-am (1982-92), and was Managing Director of Yorkshire and Tyne Tees Television from 1995-7. Gyngell has been a director of Publishing and Broadcasting since 1990 and is currently Chairman of Channel 9 International.

Like many Australians, I am direct and without guile. I certainly identify more with other Australians abroad, particularly those in media, than with the British. We understand each other and there is great humour. We share a unique brand of humour which is redolent of Australian culture and mythology. My management style, though, derives much more from Australian culture and my work experience there. I ignore class differences and I have always ignored work hierarchies. This both shocked and surprised my senior managers in the companies I ran in England. But I think it also won great loyalty from my staff.

One of my happiest times in the UK was the challenge of running TV-am, which I not only turned into the most profitable television station ever, at the time, but which I also ran as a huge family. Rivalling this experience was the unique opportunity of running Channel 9 in Australia as a very young man in a brand new industry. But by the time I was thirty-nine, I had done everything there was to do in Australian television. So to do what I wanted to do, I had to leave the country.

I travelled regularly to America and England from the 1950s for Australian television. But it was not until 1971 that I took up my first British appointment at ATV with Lord Grade. Within the confines of the various television stations I have run in the UK I have been totally at ease, but in the context of the British television industry in general I have not always been comfortable. I have never been included in the Old Boys' Club and their network. I think I have always been seen as an outsider; but then I didn't want to be completely included as it was not my culture. I think there may have been a sigh of relief in the industry when I stopped going to their meetings and was no longer there to stir them up and upset the apple-cart.

The Australia I left in 1971 was a very different country, as was its relationship with the mother country. I remember a card from my mother awaiting my arrival in the hotel when I first came to London to work. It said simply 'Welcome home darling', even though my mother was then a Sydney resident and had never visited the UK. But Australia has changed beyond recognition over the last thirty years. Britain joining the EEC was a key factor in the change. Australia is no longer close to Britain, the prime export market is now Japan. The all-white ethos has been replaced by multiculturalism, so it is a totally different society to that of the days of Robert Menzies and it really should have become a republic.

If I was starting my career in Australia today, I don't think there would be the same imperative to leave. However I think, by my nature, I would still be searching and exploring, although the global communications revolution has now reduced the significance of leaving one country for another. It's less risky and easily reversible. Having lived the best part of my life before the information revolution, living for long periods abroad has always been a question of either/or. But to some extent you always feel as though you don't belong anywhere. I now miss the seasons, the cold winters of England as much as I miss the sunshine of Australia.

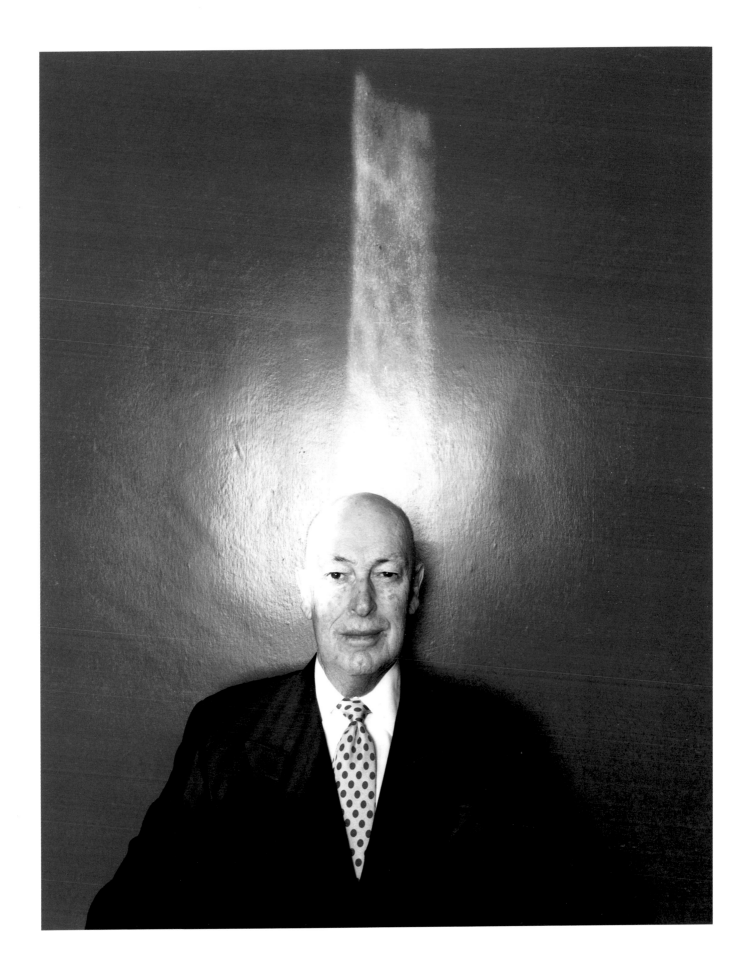

Samantha Bond
Model Agent

With models Holly McGuire and Charlie O'Neale.
Born Albury, New South Wales, 1944. Samantha Bond moved to
London in 1966. She started work as a secretary, but quickly became
one of a select group of glamour models, appearing nude in the
Observer and as a 'Page 3 Girl'. Bond was photographed by 1960s
icons David Bailey, Terence Donovan and Duffy. In 1977 she formed
her own model agency, Images, which soon became Samantha Bond
Management. Models Bond has discovered include Suzanne Mitzi,
Kathy Lloyd and Emma Noble.

How does it feel to be an Australian in the UK?

When I first came here and first opened my business, I'd be on the phone,
they'd say, disdainfully, 'Oh is that an Australian accent?'. Since Australian
soaps and Australia itself has got more of a profile over the last decade, now
when people ask the same question and I say 'Yes', they say 'Oh, how love-
ly!'. Now the English are even envious: they say, 'What are you doing here, you
must be mad!' I've always referred to Australia as home. I've never lost that. I
just love the lifestyle, it's so buzzy. There's nothing particularly Australian that
I miss because I've lived here so long. But when I watch Australian films and
hear the sound of the birds, that sound makes me feel very nostalgic.

What do you think the UK has given you that perhaps Australia couldn't have
given you?

When I came here in the 1960s, not very much was happening in Australia, it
was pretty boring: there were no street cafés, hardly any restaurants, hardly
any clubs. For a young girl it was dead. If I'd stayed there, I probably would
have married a truck driver and had eight kids and I'd probably be very
happy! Now it's a brilliant place. If I was young there now, there is no way I
would leave. Australia has already become the place to be, I think the rest of
the world will become focused on Australia, like they were focused on
London in the 1960s. It's like Australia has woken up from a sleep and
become very creative.

How was the shoot with Polly?

I enjoyed myself. Although I was a model when I was young, I hate [photo-
shoots] now. The shoot made me feel sorry for my models – I forgot it goes
on forever. She was a typical photographer and kept saying this is the last roll,
about a hundred times! She made me relax and she is quite persuasive

I never envisaged sitting on a bed with a couple of models, she's got a thing
about beds. I said to her 'Don't you make me look like some bloody madam!'

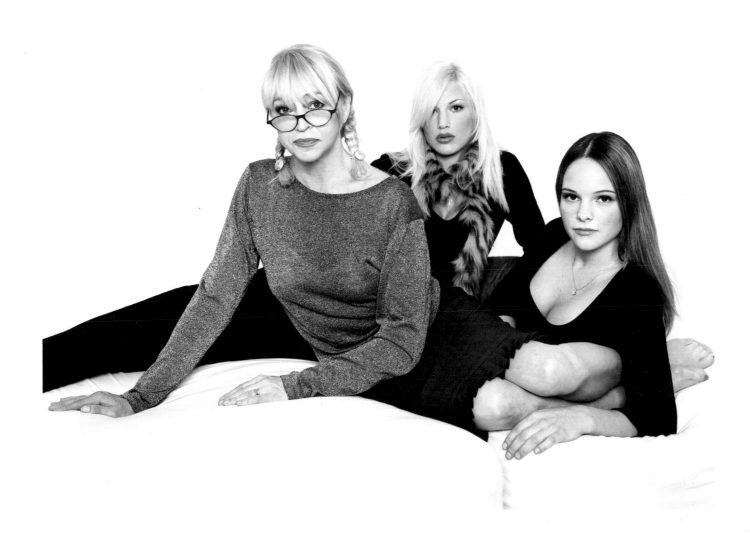

Harry Kewell
Footballer

Born in Sydney, 1978. At the age of ten, Harry Kewell was spotted as
a top prospect by the then Australian National Youth coach David Lee,
whilst playing for his local team, Marconi. He went on to win a place
at the world-renowned New South Wales soccer academy. Kewell
left Australia at the age of sixteen to pursue his footballing career and
his scholarship allowed him to train and play for Leeds United FC.
The club's 'Wizard of Oz' came to the attention of the nation during
the 1997-8 season and went on to contribute to a successful second
campaign for Leeds, culminating in a fourth place finish in the
Premiership and a place in the UEFA cup. Currently courted by top
clubs all over Europe, and rated as a future world-class talent, Kewell
remains loyal to Leeds United.

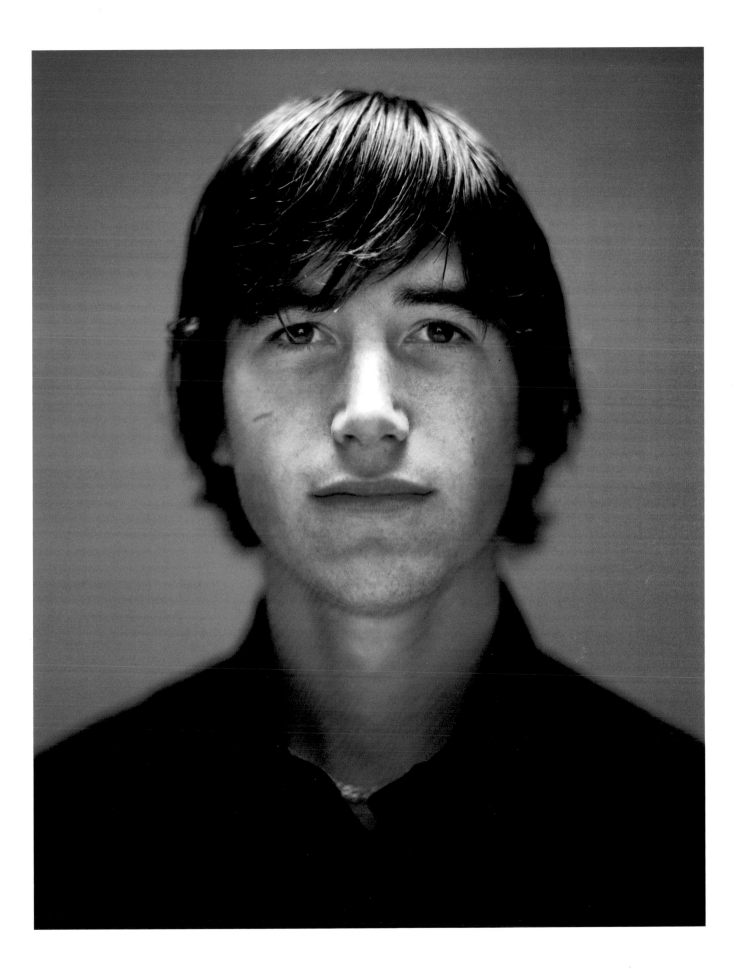

Noah Taylor
Actor

Born in London, 1969. Noah Taylor moved to Melbourne in 1973, where
he performed at St Martin's Theatre as a school student. He played
the lead in his film debut, *The Year My Voice Broke* (1986), and his other
films include *Flirting* (1992), *Nostradamus Kid* (1993) and the co-lead
in *Shine* (1996). Theatre credits include *The Seagull* and *Bloody Mama*.
His television credits include *Joh's Jury* (ABC TV) and *Inspector Morse*
(UK). Taylor has won numerous awards including the Sydney Film
Critics Circle Award and the Screen Actors Guild Award. Taylor performs
as a singer and guitarist in his bands The Thirteens and Cardboard
Box Man. His recent film *He Died with a Felafel In His Hand* (Australia)
and a project with Cameron Crowe are due for release this year.

Do you behave as an Australian now that you are living in the UK?

There seem to be a set of unwritten rules about how one should behave in
England and it's possibly got something to do with the class system. I'm quite
a chatty person in bars and I'd get myself into a bit of trouble when I first came
here, because they felt I shouldn't be talking to them or whatever. Sometimes
that bothered me but I'm learning to respect that that's the way it is. There's
really no-one you're not supposed to talk to in Australia, so it just takes a bit
of getting used to. But I'm not about to stop that either. I like living in London.
I think there's a certain freedom of being a foreigner in any country. There are
a lot of communities of outsiders in London and that's what I like about it.
Yeah, I feel a lot freer here. And I'm a bit of a voyeur, an observer, and that kind
of distance allows me to view things a little bit more objectively.

[It was only when] I went back there recently to work, I realised how Australian
my attitudes were. I want to live in the UK, but I am proud of my Australian atti-
tude of being open and accepting. I found it interesting this time to see some
sort of connection with Australia's English and Irish background and to get a
sense that [Australians] are actually made up of the people that England
wanted to boot out two hundred years ago. It's confusing being Australian,
because you can't really look back accurately at your history and background
and make sense of things; it's a country that has invented a lot of its identity.
I'm also proud of Australia's indigenous culture and I think Australians have
more of a sense of nature than Europeans.

But there is a dark side to Australia, especially in the humour and some of
the more negative things like drinking. The rest of the world's perception of
Australia is based on *Neighbours* and sunny beaches. I think the biggest prob-
lems in Australia are drugs and suicide: drug-related deaths have increased
from 50 in 1993 to 352 in 1999 . Politically, it has taken about five steps back-
wards. It's a young country battling to find itself. I think essentially it's got a
dark, melancholy nature, which is a source of material, if not inspiration, for a
lot of Australian artists.

Is there a similar contradiction in London – a bright side to the gloomy weather?

Absolutely. Personally I like London's weather. It comforts me.

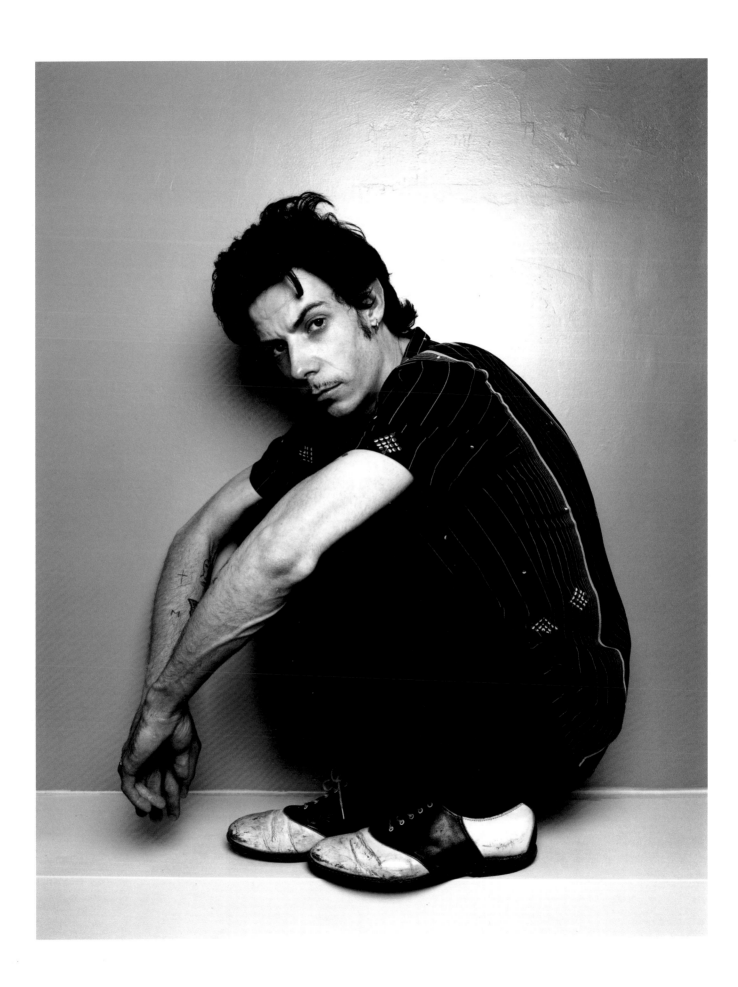

Sarah Harmarnee
Jewellery and Accessory Designer

Born in Kent, 1970. Harmarnee moved to Melbourne in 1971. She
majored in sculpture at the Victorian College of the Arts in Melbourne,
then established a jewellery line under her own name (1994-6) and
developed constructions for body adornment. Harmarnee moved to the
UK in 1996, with her collection promoted by Erickson Beamon. Since
1997, she has been commissioned regularly to design jewellery and
accessories for collections for Alexander McQueen and for Alexander
McQueen for Givenchy. In 1999, she was commissioned to design
a face piece for the Max Factor campaign featuring Madonna.

Why did you leave Australia?
Apart from a few people, I find that the Australian mentality riles me. As a cre-
ative person it's very difficult to express yourself there, particularly in the
realms of fashion, because fashion in Australia is pure plagiarism from
Europe. Unless you're copying, they don't want to know you. They gave me a
really hard time about what I did when I was there. As soon as you express
any interest in leaving Australia, they say 'What's wrong with Australia?' It's like
it's a personal insult. I think it's such a disappointment, because there is such
potential there. Imagine if it was closer, and attitudes were more open, it would
be the most amazing place in the world! But it ain't. And that's what it boils
down to. The one aspect I really respect is the colonial spirit, because through
all the odds you get through it and get to where you want to be.

Let's face it, it was a penal settlement. It was built on convicts, but at the end
of the day, they were visionaries in as much as they built something. Now the
vision's going down the tubes; my perspective is based on my last experience
there, in the world of art and fashion. Because it was settled by people who
wanted to make a new life, the contemporary interpretation of that is the land
of the *nouveau riche*. And it's really nauseating to see crass, vulgar displays
of wealth. I find Sydney, in particular, offensive. Money talks, money is the sym-
bol of success. It's a 1980s mentality that still prevails, specially in the realms
of fashion. It exists to a lesser degree in the UK, the most unlikely people have
got shitloads of money and you wouldn't even know it. And that's chic. But by
the same token, I would hate to be a kid growing up in London. I grew up in
Frankston, near Melbourne, and I had two horses. The hardest thing for me to
deal with here are the lack of space, the lack of light and the weather.

London is a really fucking hard town. To make it, you've got to be passionate
and have conviction and be so good, and you've got to go for what you want,
and that's how it comes to you. The UK has given me freedom, recognition
and an arena to express myself to the world.
What happened on the shoot?
I refused to wear my jewellery. It's a portrait about me and I don't want my work
in it. What I'm most passionate about is horses and I said I want to be shot on
a horse [*laughs*]. Polly really gets into the character and has a fantastic sense
of humour and a great sense of irony. She invites you to take her on a journey
and if you want to take her, you do.

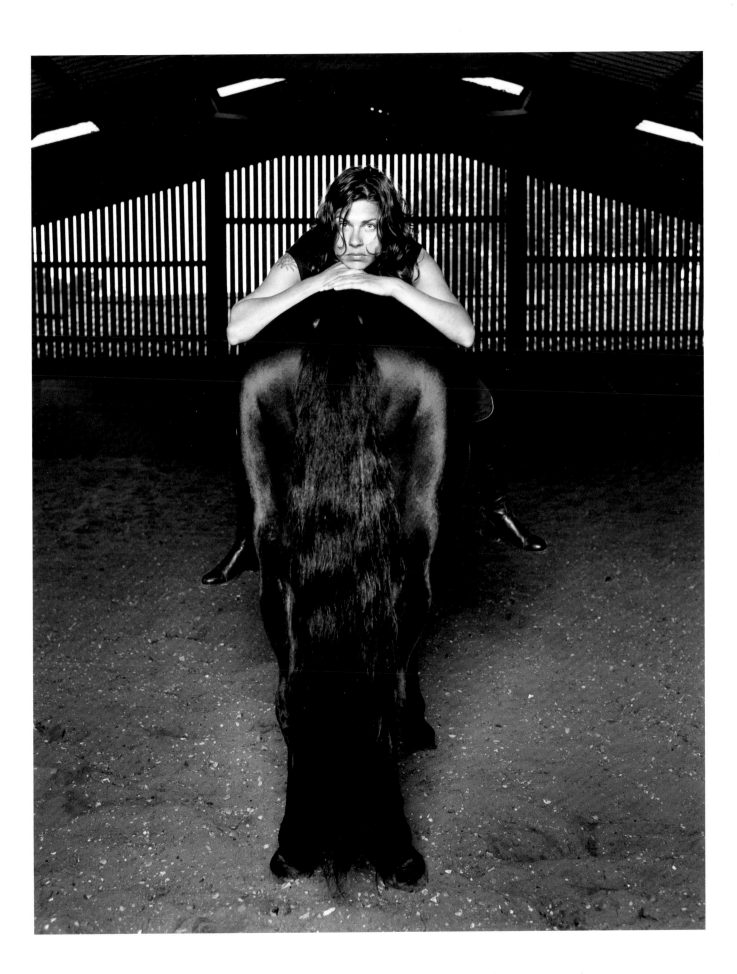

Clive James
Author, Broadcaster

Born in Sydney, 1930. Clive James studied at Sydney University and Cambridge University, where he was President of Footlights. His published work includes three best-selling volumes of autobiography, four novels and numerous collections of travel essays, journalism, poetry, and literary criticism. He was television critic for the *Observer* from 1972 to 1982 and is a contributor to the *New Yorker* magazine. Since the 1980s James has hosted celebrity talk shows, and written and presented documentaries for the BBC and ITV. In 1995 he co-founded Watchmaker Productions, which produces studio shows and film specials. He was awarded the Order of Australia in 1992.

Geoffrey Crawford LVO
Press Secretary to H.M. The Queen

Born in Sydney, 1950. Geoffrey Crawford studied Government at the
University of Sydney and entered the Australian Department of Foreign
Affairs in 1974. After completing Arabic Studies in Cairo (1978-80),
he was appointed Second Secretary to Jeddah (1980-82) and First
Secretary to Baghdad (1983-4). Crawford joined the Royal Household
in 1988 as Assistant Press Secretary to The Queen and transferred to
the Civil List in 1991. He was appointed Deputy Press Secretary in
1993 then Press Secretary to The Queen in 1997.

Your recollection of the shoot with Polly?
I was photographed in the Waiting Room at Buckingham Palace. I think it [the
choice of room] was as much for the colour of the wallpaper, which was a pale
green, as any other technical reason.
Do you think being an Australian helps in what is a deeply British institution?
Perhaps. I think Australians generally are forthright, resourceful and adaptable
people – inevitably, products of our history and environment. In my own travels
around the world, I have often been surprised and delighted to come across
Australians doing interesting and worthwhile things, in all sorts of unusual
places. Naturally, as an Australian, I take pride in seeing these people – such
as the Australian doctor working with lepers in rural Nepal; the Australian aid
worker in Mozambique; or the Australian businessman striving to establish a
commercial link in Oman.
Do you think being an Australian has allowed you freedom to move around the
established class system?
To some extent – because you come from outside, and therefore cannot be
placed so easily into an accepted social category, you have a little more lati-
tude and scope.
What do you miss about Australia?
The light. In Britain it is generally opaque. It's the clarity of light, the sharpness
of the image I notice most of all when I go back to Australia, and the space
and the feeling of energy.
Has your view of Australia changed?
Yes. Australia is now a very dynamic and self-assured place. There is less of
the mutual stereotyping [between Australia and Britain] which one used to
hear. It's now a much more mature relationship.

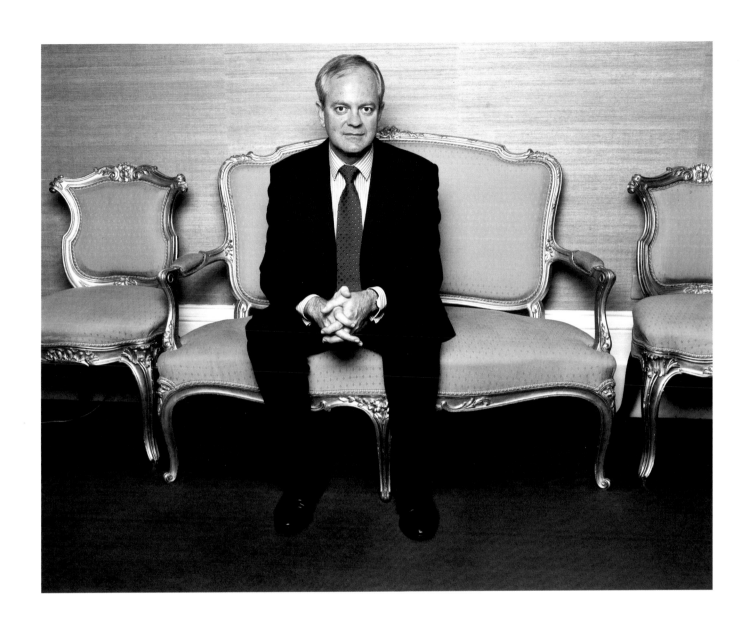

Elisabeth Murdoch
Broadcasting Executive

Born in Sydney, 1968. After graduating from Vassar College, USA
(1990), Elisabeth Murdoch joined the Nine Network in Australia as a
Promotions Assistant and then worked as a researcher and producer
for *A Current Affair* (1991). In 1993 Murdoch was appointed Manager of
Programming and Promotion at Fox Television Stations in Los Angeles
and later that year became the Programme Director of KSTU – Fox 13 in
Salt Lake City. She was appointed Director of Programme Acquisitions
at FX Cable Network in LA (1994-5) and in 1995 became President and
Chief Executive Officer of EP Communications, LA. In 1996 Murdoch
joined Sky in London as General Manager, Broadcasting, and in
1998 she was appointed Managing Director of Sky Networks, BSkyB.

What does it mean to you to be an Australian?
I am extremely proud of my Australian heritage. Now that my accent is stub-
bornly American, I have to remind people that I was Australian born and bred!
I think all Australians have an interesting mix of underdog determination and
self-confidence, as well as a big dose of modesty. Personally, Australia holds
so many wonderful childhood memories for me. And some not so wonderful,
such as freezing at Geelong Grammar and never getting the hang of netball.
From the outside, I do not think the country has evolved as much as it should.
I question whether new ideas and new opportunities are being given the nec-
essary environment to thrive. I think the referendum was a sadly missed
opportunity for Australia to define itself as a nation.
What is it about the UK that has kept you here?
The Brits have a huge soft spot for Australians. I have enjoyed every minute of
my time in the UK. Despite appearances from the outside, the UK is ablaze
with new ideas and opportunities, particularly in the media sector. It is a very
exciting time to be a part of a very dynamic environment.
How was the shoot with Polly?
Polly was huge fun to work with. I couldn't possibly share the stories she told.
I think I was probably the dullest subject for her, having heard about the antics
of the others!

Sir Robert May
Chief Scientific Adviser to the UK Government

Born in Sydney, 1936. Trained as a theoretical physicist/applied
mathematician, Sir Robert became Professor of Physics at Sydney
University(1969-73) and Professor of Zoology at Princeton University.
In 1988 he was appointed to a Royal Society Research Professorship
in the Department of Zoology at Oxford University, from which he is
on leave during his appointment (1995-2000) as Chief Scientific
Adviser to the UK Government and Head of the UK Office of Science
and Technology. Sir Robert was awarded a Knighthood in 1996 and
the Companion of the Order of Australia in 1998, both for services
to science. He received the 1996 Crafoord Prize and the 1998 Balzan
Prize for his work in ecology and biodiversity.

How would you compare the academic experience in Australia and the UK?
I would say the similarities are much more important than the differences. The
collective enterprise that you'll find in the Zoology Department in Oxford is not
that different from what you'd find in a zoology department in Australia. And
even if you look at the university systems more generally, there is the current
problem of encouraging diversity within a system [in the UK] which now has
120 universities where it used to have only thirty or sixty; many of those prob-
lems are interestingly similar to those in Australia which has also expanded
recently from seventeen to thirty-seven universities.
Is there any way of distinguishing the academic intellect in the two countries?
The answer to that is no. The people who are doing research in ecology, biol-
ogy or physics in Australia and Britain are going about it using the methods
which have evolved over the last few centuries and are extraordinarily suc-
cessful. You would not be able to pick up a paper or look at a piece of work
and say 'That was an Australian', in the way that perhaps you could in the art
world, where there would be different cultures and different traditions. Australia
and Britain, like Sweden and Switzerland, and Israel and the United States,
tend to do [research] in an idiom which is infested with the irreverent young,
and that is demonstrably the best atmosphere for producing good science.
You would find differences if you looked at risk-taking entrepreneurship, risking
everything you've got on a throw of a dice in the commercial world. You will find
North America more adventurous than Britain or Australia, although that is
changing.
As one of the creators of the chaos theory, is there some way you could put a
chaos spin on Australia?
The only relevance it has is when I took up this job, one of the tabloids had a

wonderful little snippet, 'The New Chief Scientist is an expert on chaos. He is
about to discover he has a lot to learn in Whitehall'. I knew I had a lot to learn,
but I wouldn't say it was chaos [amused]. Complicated, but not chaos.
How was the shoot with Polly?
Sitting there with the Tasmanian wolf [or tiger], I had the distinct feeling of hav-
ing wandered into a Monty Python Dead Parrot sketch. But I trusted her, all
intuition to the contrary [laughs].

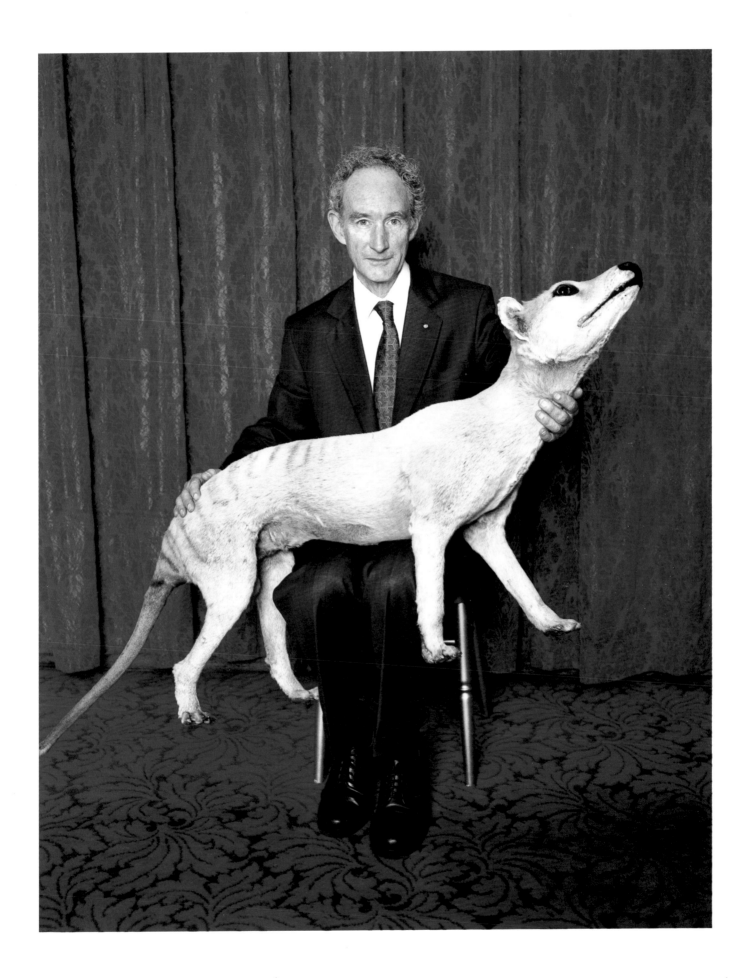

Leanne Benjamin
Principal Ballerina, The Royal Ballet Company

Born in Rockhampton, Queensland, 1964. Leanne Benjamin has danced
with many of the world's major ballet companies including all three
leading companies in London – Sadler's Wells Royal Ballet, London
Festival Ballet (English National Ballet) and the Royal Ballet, Covent
Garden, where she has danced virtually every leading role in the
repertoire. She leapt onto the British ballet scene at the tender age of
sixteen when she won the RAD Adeline Genée Gold Medal as well as
the Prix de Lausanne Gold Medal while still a student at the Royal Ballet
School. Apart from a year performing in Berlin with the Deutsche Oper,
she has always lived in London since leaving Queensland. Benjamin
is currently enjoying performing a varied repertoire at the newly
refurbished Royal Opera House, as well as appearing as a guest artist
with ballet companies around the world.

How do you feel as an Australian in the UK?
Fit in? I guess I do, I am Australian, but after so many years I have become
influenced by this place – something I mainly notice when I go back to
Australia. Don't get me wrong, ask anyone at work, or at home, and they will
tell you I have more in common with a dingo than an English rose. I did yearn
to go back to Australia for many years until I was given a golden opportunity
but, much to my surprise, I could not leave. My friends are here, as well as
most of my siblings, and although I miss my parents terribly, I couldn't justify
giving up everything I have worked so hard to build here: a beautiful flat, rela-
tionships, and a meaningful career (I'm especially looking forward to the open-
ing of the re-developed Royal Opera House). Of course I adore the
Australians, and I love being with them when I go back for visits; mind you,
these days, it seems there are as many Aussies in London as in Sydney!
What did you think of the shoot?
I loved Polly! We got up to all sorts of things... had I been asked before the
shoot, I never would have done them. First I had to dye some *pointe* shoes
red (I am not the most domestic person in the world). After this, furniture had
to be moved around, but not by my diminutive frame. Then to the embarrass-
ment of Polly's assistant, quite a few items of clothing hit the floor, something
of which my Catholic bishop uncle would not have approved. I like these shots
– I think they are very sexy, it's just a good thing that I have no intention to run
for any public office!

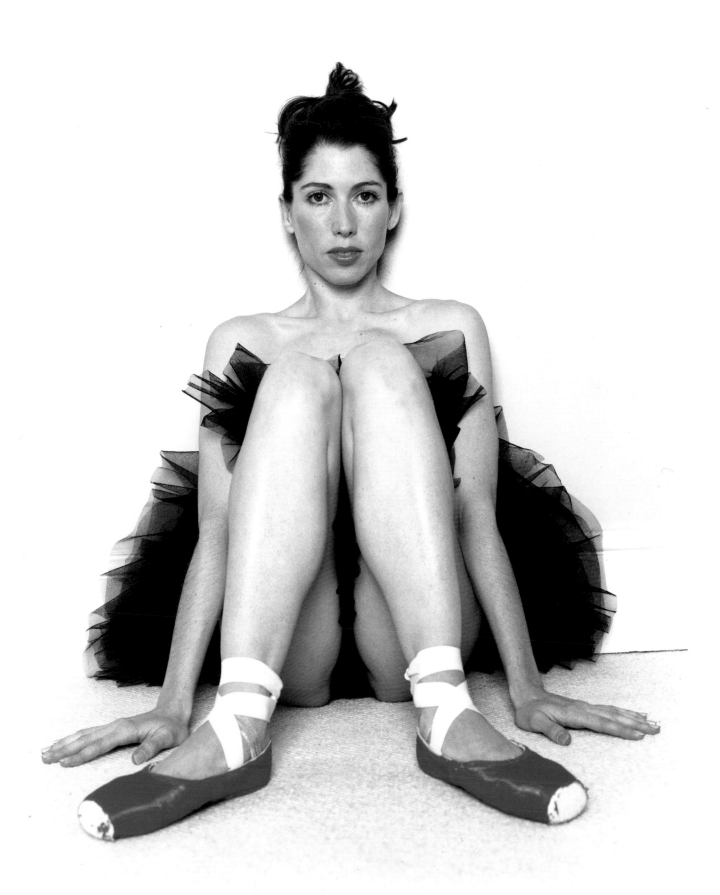

Yvonne Kenny AM
Opera Singer

Born in Sydney, 1950. Yvonne Kenny came to London in 1974 and
made her operatic debut in 1975. After winning the Kathleen Ferrier
Competition she joined the Royal Opera House, Covent Garden
in 1976. Kenny also appears regularly in concert internationally
and has been singing for Opera Australia since 1982. She has been
asked to perform as the Countess in *Capriccio* for the Sydney
2000 Olympic Arts Festival. Her numerous recordings include Mozart's
Le Nozze di Figaro. Kenny was made a Member of the Order of
Australia for Services to Music in 1989 and in 1999 was awarded
an honorary Doctorate of Music by the University of Sydney.

How was the shoot with Polly?
It was in the [Coliseum] theatre and it was an hour before a dress rehearsal
for *Der Rosenkavalier* which is one of my best roles and Polly wanted to
shoot me in costume. It was a strange feeling really. A dressing room is a
very private place and you feel very vulnerable and exposed, because
you're creating your character with make-up and wigs, so we compro-
mised on what Polly could shoot. I think she would have preferred to have
seen me without my wig and with my hair in pins. But I didn't want to do
that. I felt I either wanted to be me, completely me, in ordinary street gear,
or the character. But I think she was always looking for something more
gritty. The shoot was fun but quite a contrast to what I expected.

What are your feelings about being an Australian in the UK?
Perhaps British people do like to feel that they are in some way superior
to us – there is a hint of condescension particularly in the press –
because of the fact that we are a new country and we don't have the
same depth of sophistication or culture. When you think that Captain
Phillip and the First Fleet were arriving to form the very first white settle-
ment at about the same time that Mozart was composing his opera *Don
Giovanni* it puts it in perspective. But what does exist in Australia, which
is so wonderful, is a freshness, an ability to try anything. I think we're
much freer in our creativity. We're not locked into a traditional way of
doing things. The Sydney Opera House opened just as I left to go to
Milan as a student in 1973. The impact that's had on our cultural lives is
just fantastic. I think it was the catalyst for the development of a lot of
things and I think we've grown amazingly quickly. The world is now a
small place. And I think we are fast learners.

What are the downsides of Australia?
Because of its geographical isolation, it's quality in the arts more than quan-
tity. There is only one main opera company and some regional companies
which work on a more part-time basis, so you have fewer opportunities. In
the UK there are many more companies to work with but the market is more
competitive. It's a good base for me, to continue that dual existence.
Eventually, when singing is no longer the priority, I can imagine going back
to live in Australia. I think the lifestyle and the climate make you a lot more
relaxed and happy. The sun and the clarity of the light – it's very optimistic.

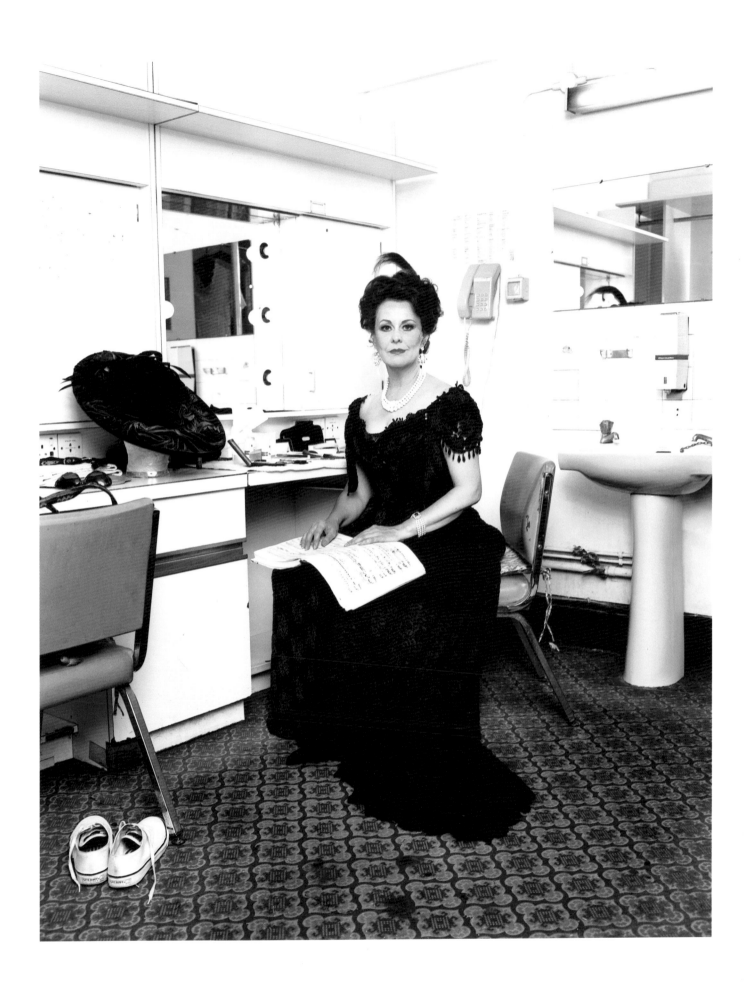

Professor Germaine Greer
Author, Academic

Born in Melbourne, 1939. Professor Greer graduated with BA (Hons) from Melbourne University (1959), MA (Hons) from Sydney University (1962) and PhD from Cambridge University (1967). She was the Assistant Lecturer, then Lecturer in English at the University of Warwick (1967-72) and Professor of Modern Letters at the University of Tulsa (1980-83). Professor Greer was the Special Lecturer and Unofficial Fellow at Newnham College, Cambridge from 1989 to 1998. She has been the Director of Stump Cross Books since 1988 and the Professor of English and Comparative Studies at the University of Warwick since 1998. Professor Greer's publications include *The Female Eunuch* (1969), *Daddy I Hardly Knew You* (1989) which won the J.R. Ackerley prize, and *The Whole Woman* (1999).

Did the shoot with Polly differ from other shoots you've had?

Not really. I just don't like being photographed. In the end the image is nothing to do with me. It was my idea to take my clothes off though, because I did not fancy being portrayed on my bed like an old lady in a nursing home in me [sic] cardigan. I don't usually have any clothes on in that room and I don't have any clothes on for a good half of my life. The photograph is really quite childlike. I think there is a certain amount of playfulness in it. It might surprise people to discover that sixty-one-year-old ladies can be playful.

Will it surprise people to know that Germaine Greer can be playful?

Oh, I think they should be used to it by now. But they probably aren't: stereotypes die hard. I think stereotypes should be challenged wherever possible, but I don't make a point of it.

Do you think it's easier to be a maverick here than in Australia?

One of the problems in Australia is this petulant anti-intellectual bias, people don't actually want you to be clever. As far as I could see, I couldn't make a living in Australia. There aren't enough readers, there aren't enough quality newspapers, they don't pay enough money and they seem to think they're entitled to my services for free.

Maybe there is a sense of ownership because you're seen as an Australian icon?

How could I be? I've never been offered an Australian honour, I've never been offered an Australian job. I've been offered an honour in the English honours list and refused it. But the Australians will never offer me one.

Do you feel a sense of rejection?

No, I'm glad it's the way it is. Because I have yet to form a desire to go home. And I honestly think in the year 2000 I can't go back as a white Australian to white Australia. Australia has to realise its Aboriginality, there is no future for Australia unless they do that. The Aborigines need their sovereignty to be recognised and they need to have a treaty. They lost their country without ever being given the opportunity to defend it, and it's outrageous. The treaty was drawn up and it collapsed, and it could be revivified tomorrow. I don't know what's going to happen during the Olympics – I hope there is deep embarrassment.

What is your view on the status of women in Australia?

The good thing about Australia is that it's capable of putting good ideas into action. There is a lot of Australian contribution, for example, to feminist theory, which is original and exciting, and liberating, in the sense that it suggests more options, so Australian feminism is conceivably the best feminism in the world. I think that Australian women are growing up with a very distinct idea of who they are and what they can do. [But] let's not get too starry-eyed about this. The whole nation seems to be drugging itself stupid. This is to do with demoralisation, and a feeling of pointlessness and boredom, the only adventure you can have is with a needle in your vein.

Why isn't Australia the Shangri-La that its image evokes?

When people think of a place like Australia they think of it as a place for a holiday. [But] you can't live your life on holidays, you'll go mad. You have to have some feeling of purpose and I think that's what hardest to manage in Australia and partly why they can't get it right. People in Australia are generally fairer-minded and more honest about who they are and where they come from. But in the end, there's also this fatal lack of pressure, so people don't do better. Mind you the field where this is not true is, of course, sport.

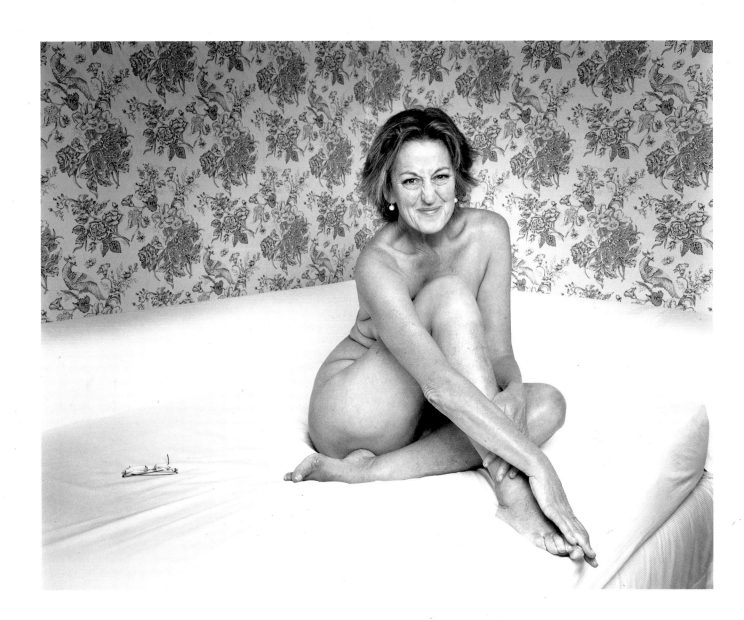

Nick Cave
Musician, Author

Born in Warracknabeal, Victoria, 1957. Nick Cave left Melbourne for
London in 1980 with his band The Birthday Party. They re-assembled
as The Bad Seeds in 1983 and released the first of eleven albums to
date, *From Her to Eternity*. Cave moved to Berlin in 1984 and his first
book *King Ink* was published in 1988, the same year The Bad Seeds
appeared in Wim Wenders film *Wings of Desire* and scored John
Hillcoat's *Ghosts of the Civil Dead*, whose filmscript Cave helped to
write. His novel *And the Ass Saw the Angel* won *Time Out*'s Book of
the Year Award (1990). Other albums followed, including *Murder Ballads*
(1996) which included a collaboration with Kylie Minogue. In the same
year, The Bad Seeds scored John Hillcoat's film *To Have and to Hold*
and *King Ink II* was published. The band is currently recording a
new album to be released in 2000.

What has kept you in the UK?
I left Australia because, musically, we were at a dead end and we were get-
ting nowhere, with very little support from Australia, apart from a bunch of
die-hard fans and it was necessary to come to England to get the recogni-
tion. Sadly. The great thing about making music in Australia is that in those
days, you knew, deep down, that you were never, ever, going to get any-
where. Consequently you were free to make whatever kind of music you
liked because it just didn't matter and, as a result, unique and idiosyncratic
music came out of, particularly, Melbourne at that time. You could then
bring that to England, which seemed to enjoy eccentric music, eccentricity
generally. The problem with England is you're given no time to develop. So
as soon as you could stick three chords together some record company
person is putting you in the studio and calling you the new sound of what-
ever decade you're in and you don't really know what you're about. I don't
think the Australian music industry at that time, and I'm not convinced that
it's any different now, would have recognised anything great if they had
stepped in it [*laughs*].
Do they recognise it once you do well?
Once they run it in the English press, yes. Then you have to make the long trip
back home. It's a roundabout way of getting your foot in the door in Australia.
Do you enjoy the recognition now when you go back?
Yeah, twenty years on, the Australian record industry awarded me an up-and-
coming songwriter of the year, or something like that. By that stage it was all
too late and I didn't attend the ceremony. In London you realise that you can
survive without being complicit with the industry here. That's the way we oper-
ate. We have an independent record company and we don't sign contracts.

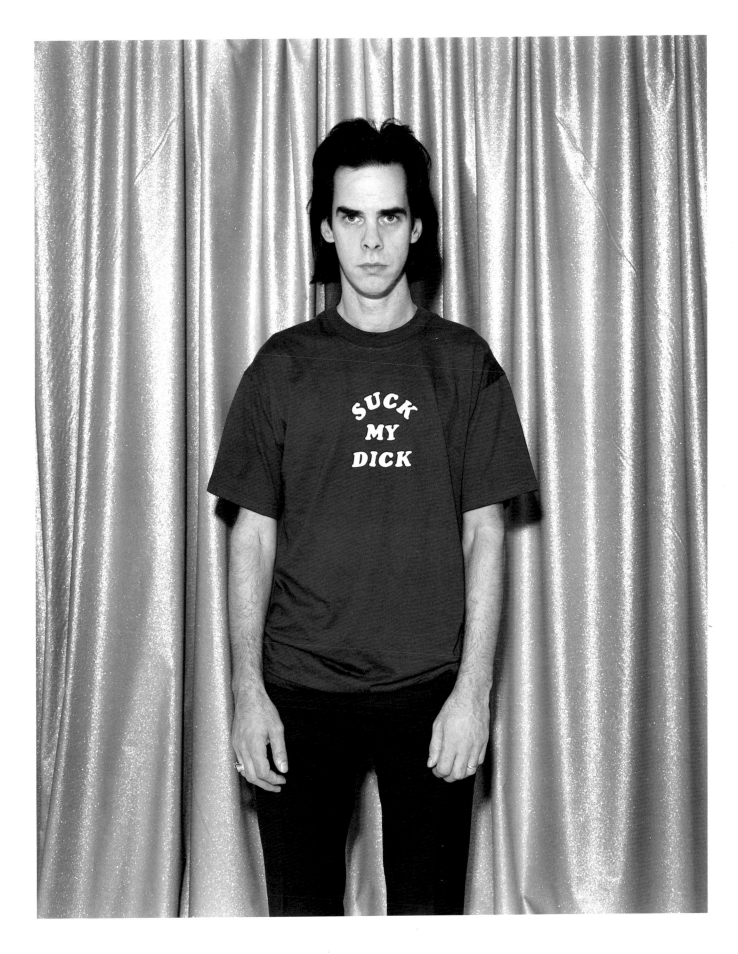

Professor Sir Peter J. Morris PhD, FRCS, FRS
Surgeon, Scientist

Born in Horsham, Victoria, 1934. Professor Sir Peter Morris graduated
in Medicine from Melbourne University. After initial training at
St Vincent's Hospital he continued his training in the UK and the USA,
mostly at Harvard and in 1967 returned to the Melbourne University
Department of Surgery. In 1974 he was elected to the Nuffield Chair
of Surgery and a Fellowship of Balliol at the University of Oxford.
At Oxford he has developed a major academic department of surgery
as well as an internationally renowned clinical and research programme
in transplantation. Sir Peter is a Fellow of the Royal Society and a
Foreign Member of the Institute of Medicine of the National Academy
of Sciences in the USA. He has received many honorary Fellowships,
degrees and prizes including the Selwyn Smith Prize of Melbourne
University and the Lister Medal. He was knighted in 1996 for services
to medicine.

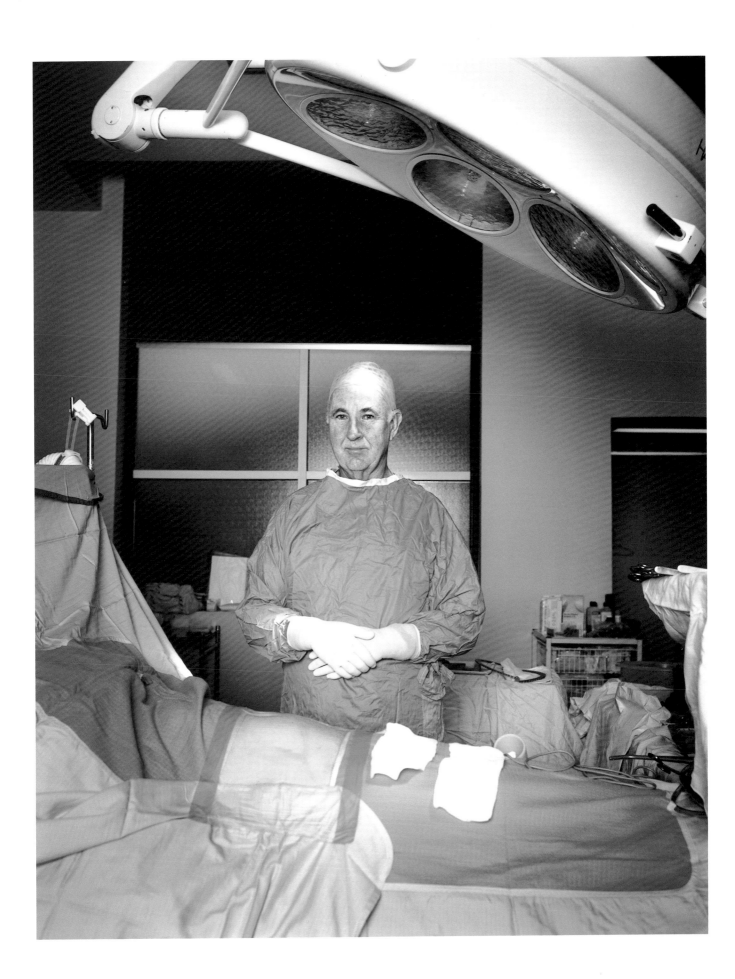

Natalie Imbruglia
Singer, Songwriter

Born in Sydney, 1975. After leaving school in 1991, Natalie Imbruglia
appeared in several television commercials and then joined the
television soap *Neighbours* as the character Beth Brennan. She moved
to London in 1996, began writing songs and signed a record contract
with RCA in 1997. Her first album *Left of the Middle* was released
that year and has sold more than six million copies worldwide.
The single *Torn* topped the UK charts for nine weeks and earned
Imbruglia a string of awards, including Best Song at the MTV Europe
Music Awards. She has also received two Brit awards, six Australian
ARIAs, and been nominated for three Grammys. After performing at
several European festivals in 1998, she toured the UK with nine
sell-out dates. She is currently writing songs for her second album
which will be released in 2000.

Speaking from her hotel room in Beverly Hills, USA

Your recollection of the shoot with Polly?

Yeah, my arse was killing me [*laughs*]! It was winter time, cold and I was sit-
ting on a wooden floor and we were all laughing at the situation. The things
you go through. It was good fun. You can't even tell [I was sitting on the floor],
because it's a head shot. I've never had a shoot in my house before. I don't
really like doing things at home. But the whole idea of the shoot, of 'Aussies
doing good overseas', felt right to do at home.

What's kept you in the UK?

Definitely the edge. People work very hard here. Not that they don't in
Australia, but Australia as a country is quite easy. You've got sun. If you're
struggling, it's easier to struggle in Australia because, hey, the sun's shining,
so 'no worries, mate'. But I think in England there is this constant struggle just
to get by. Even when you reach a stage where you are more secure in your
work and financially, it still feels like an uphill battle, but in a good way. There
are just so many people plugging away and working hard here. To have
achieved the same things in Australia: it's smaller, the stakes are higher and
once you've done the rounds once, that's that. I think when you first go over-
seas, it rubs off on you a little bit. You get swept away with it. I've been here
for five years. I've gotten over being impressed with the whole change of cul-
ture and I'm quite happy to be an Aussie and have my accent. When you first
go to England, you feel you don't fit. But now, I just laugh about all the things
that are Australian about myself, I embrace them much more than I did. The
one thing I'm proud of in Australia is that we don't have the social class sys-
tem. Here, you know your place, and there's no moving across circles. In
Australia, the rich mix with the poor, it's about what kind of a person you are.
And I think that's great.

Are you torn between the two countries?

I do struggle with that actually. I think Australia is my favourite country. Having
travelled all over the world, it's the most beautiful country. But there's an edge
that London gives me that I can't give up just yet. For quality of life I would be at
home in Australia, but career-wise at the moment, I like being in the melting-pot.

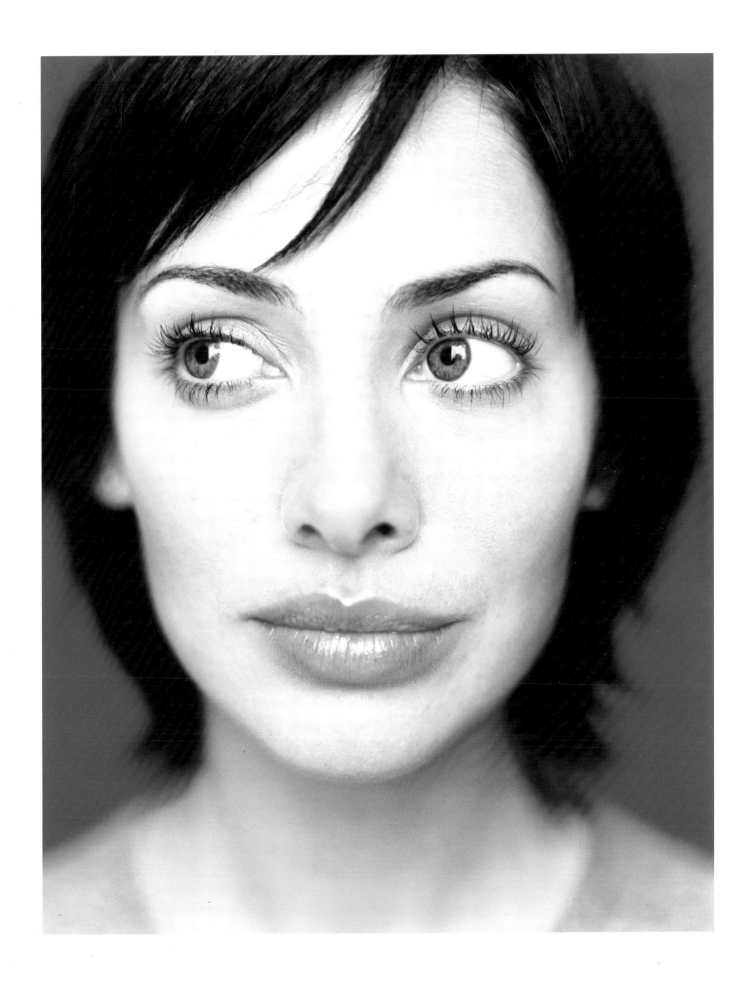

Cate Blanchett
Actress

Born in Melbourne, 1960. After graduating from the National Institute
of Dramatic Art in Sydney in 1992, Cate Blanchett joined the Sydney
theatre group Company B. She appeared in the Sydney Theatre
Company's *Top Girls* and *Oleanna*, for which she was awarded
the Sydney Theatre Critics' Rosemount award for Best Actress.
Her television credits include Australian Broadcasting Commission's
Bordertown (1994). Her feature film credits include *Paradise Road*,
Thank God He Met Lizzie and *Oscar and Lucinda*. In 1999, Blanchett
received a Golden Globe Award for Best Actress in Drama, and an
Oscar nomination for her lead role in *Elizabeth*. She also co-starred in
Pushing Tin and *An Ideal Husband*, and played the lead in *Plenty* in
the West End. The year 2000 sees the release of *The Talented Mr Ripley*
and *The Man Who Cried*. Blanchett is currently working on Sally Potter's
film *The Gift* and on Peter Jackson's trilogy *The Lord of the Rings*,
to be shot in New Zealand.

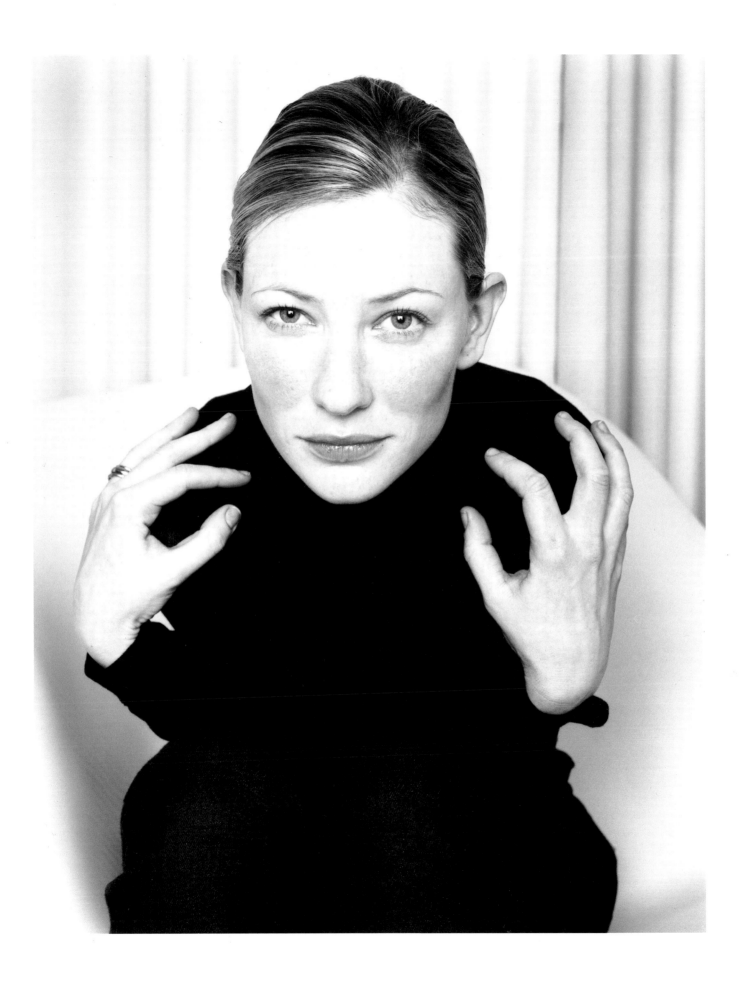

Richie Benaud OBE
Cricketer, Commentator

Born in Penrith, New South Wales, 1930. Benaud made his first-class debut for the Central Cumberland District Cricket Club for NSW vs Queensland at the Sydney Cricket Ground in 1949. He played in sixty-three Tests for Australia, never losing a Test series as Captain in twenty-eight Tests, and was the first cricketer ever to achieve the double of 2,000 runs and 200 wickets in Test cricket (vs South Africa in 1963 at the 'Gabba). Benaud has covered almost a thousand Tests and limited-over Internationals as a journalist and commentator for BBC Television (1960-99), for Channel 9 Television since 1977 and for Radio 2UE since 1989. Benaud now commentates for Channel 4 in the UK from April to September, and for Channel 9 in Sydney from October to April. He has published *Anything but... An Autobiography* and seven books on cricket.

Benaud's response to questions, faxed from his Sydney home in Coogee

I have been visiting England over a period of forty-seven years, first as a player with Australian teams and then as a television commentator and cricket writer. I don't know if there is anything that distinguishes me as an Australian, other than accent, though even that, from what everyone tells me, is a mixture of Australian and British these days. It's always difficult to define something like being Australian, or British for that matter. It might be more accurate to offer something my parents taught me, which was 'do your best, never give up and don't take yourself too seriously'.

Being an Australian in England is something I have always thoroughly enjoyed. I loved London from the first moment I arrived and have always thought of it as a great city. When I tried to learn about television in 1956, it was British commentators I studied and it was the BBC with whom I hoped to work. Australia's image is changing, and Australia changed to a certain extent when Britain went into the Common Market. There is now more emphasis in Australia on Asian countries and neighbours, even though recently Australia heavily voted down the thought of becoming a republic, and Australia's crick-eters still have as their ultimate aim to tour England with an Australian team and retain or regain the Ashes.

The shoot with Polly was at the Sydney Cricket Ground shortly before Australia played India in the Third Test match of the series. I was very impressed with Polly's technique, she knew precisely what she wanted, was quick and very thorough.

The Old Members' Stand, where the photograph was taken, is a Heritage list-ed building and is steeped in tradition. Some of Australia's greatest sportsmen have walked down those wooden steps and on to the ground in front of 40,000 enthusiastic spectators. It was on the same pitch that Don Bradman made his 100th first-class century, Shane Warne took his 300th Test wicket and I played my first Sheffield Shield match, and my first and last Test matches.

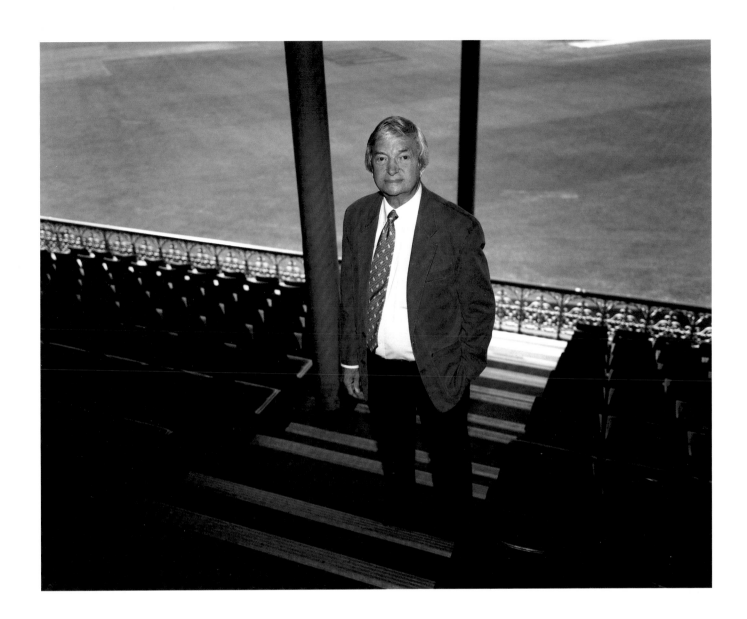

Professor Sir Alec Broers, PhD, FRS, FREng
Vice-Chancellor, Cambridge University

Born in India, 1938. Professor Sir Alec Broers attended Melbourne University then Cambridge University (1960), where he gained a BA, PhD and ScD in Electrical Engineering. In 1965 he moved to the USA where he worked for IBM for almost twenty years. Sir Alec returned to Cambridge University in 1984 when he was elected Professor of Electrical Engineering and Fellow of Trinity College (1985), and subsequently Master of Churchill College (1990) and Head of the University Engineering Department (1993). He was appointed to his present position in 1996 and was knighted in 1998. He has served on numerous British Government, EEC and NATO committees and received a number of awards, including the American Institute of Physics Prize for Industrial Applications of Science. Sir Alec was appointed Member of the Council of Melbourne University (2000).

What defines you as an Australian?

I like to think that I am an open and pragmatic person who enjoys a joke and doesn't take himself too seriously; my idea of a typical Australian. It is also my happy memories of the gum trees and of Melbourne, a city with everything, but one that isn't too big.

What is it about the UK that brought you back from the USA?

It's not so much the UK as Cambridge. I wanted to return to this international place with its vast intellectual breadth and its uncanny way of coming up with ideas that change the world. I wanted to get back to pure research and enjoy the stimulus of colleagues from a broader spectrum of subjects.

Can you compare the academic cultures in the two countries?

This is all but impossible. My time in the USA was spent in industry where naturally there was emphasis on the applicability of one's research. If there is a difference between academic research in the USA and in the UK, then it's the greater emphasis on applicability in the USA. The attitude in Australia falls somewhere between the USA and the UK.

What is your view of Australia now?

Australia is much more sophisticated now than when I left it. But, as it has come into its own and established its own identity, it has retained its friendly, open and bright character. Australia has also become very competitive and professional. The Australian universities are world-class; they have managed to establish themselves internationally and avoided becoming insular.

How did you find the shoot with Polly?

That was fun. We actually had a technical discussion on the shoot. She wanted me to sit in this huge chair but I had to point out that the chair would not look huge in the photograph unless there was something to indicate its scale.

I'm a microscopist and know that it is essential to indicate the magnification of a picture otherwise no one knows how big anything is. Without the presence of a standard-sized object other than the chair – a milk bottle or a newspaper for example – I would merely look like a very small person in a standard-sized chair. People are variable in size but chairs are not. Polly wanted the chair in the middle of a large lawn so there was no size reference and we couldn't solve this problem.

Where science meets art?

Where science meets art, I think, was definitely the issue. We picked a more conventional-sized chair, one that I spend a lot of my life sitting in while I chair the innumerable committees that govern the university.

So the one you chose?

The high-backed chair that normally sits in the University's medieval Council Room.

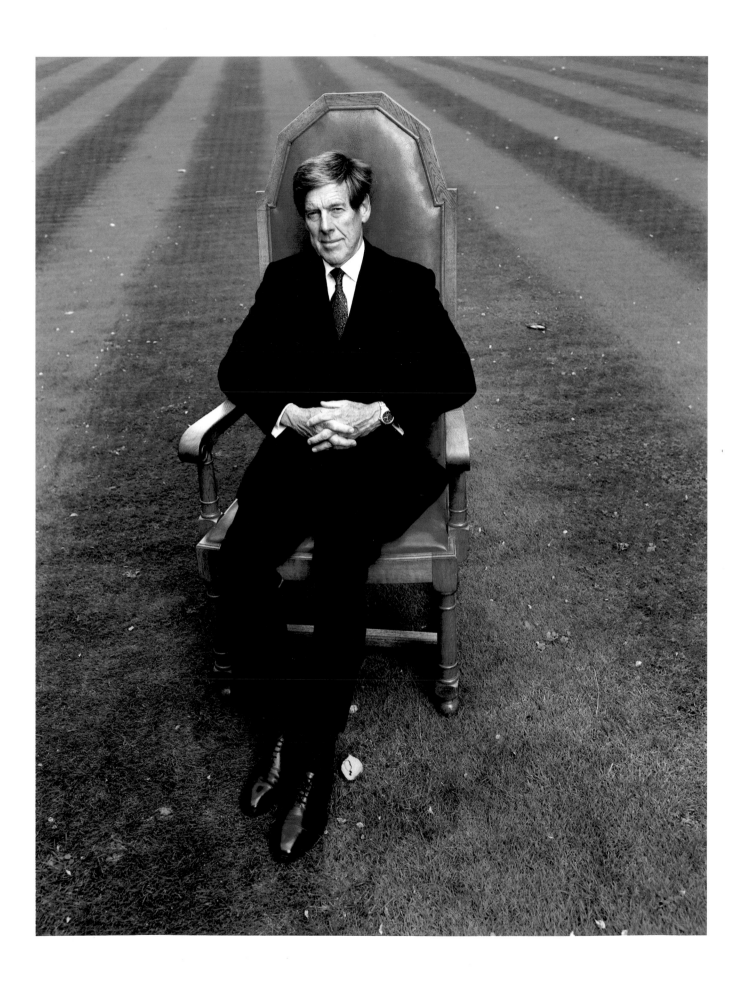

Bob Godfrey
Animation Director

Born in West Maitland, New South Wales, 1921. Bob Godfrey left
Australia for the UK in 1922. He studied commercial art at Leyton Art
School, London (1935-7) then took a job in advertising at Unilever. After
completing his war service, he worked in merchandising for the Rank
Organisation and in 1950 he entered the film business as a scenic artist
for the Film Producers Guild. From 1955 to 1965 his company,
Biographic, made animated TV advertisements and in 1965 he set up
Bob Godfrey Films to make animated films for TV, including *Rhubarb
and Custard* and *Henry's Cat*, a series for children. Godfrey has
received four Oscar nominations and won an Oscar for Best Short
Animated Film, *Great*, in 1975. His film *Millennium: The Musical*
was broadcast on Channel 4 on New Year's Eve, 1999.

Speaking from his London studio

Are there any Australian characteristics which you have identified?
Australians are great travellers and back in the 1960s there were an awesome
number of Australians in London and a lot of them came to work for me. There
is a craziness in Australians and it probably comes out in these films.
Australians are a little bit laid-back and less inclined to submit to authority
[*amused*]. They don't look both ways trying to cross a road and if someone
tells them to do something, they'd probably tell them to go and get stuffed.
Do you share that contempt for authority and is it reflected in your animation?
It comes out in my work. It's an anti-authoritarian kind of attitude. I'm against
anybody who starts laying down the law. If you work in a creative field you're
bound to come up against rebellious people, maverick kind of people. I
wouldn't say the Australians were in the Ned Kelly mould. But they are maver-
icks. This is not a bad thing in our industry, where they tend to be a bit ortho-
dox. To be on the outside of things is not always comfortable but it's the only
course that you can follow because you don't want to do the other stuff that
other people do.
How do you think Australia has changed?
Mainly the problem is of the lack of my kind of work in Australia, unfortunately,
because Australia is very much sewn onto the side of America. [But] it's an
independent country and I think that kind of independence should be encour-
aged and fostered. There are so many nations there, but there is a nationhood
and the national product should be developed and it should be encouraged.
I know there is talent there but there is tremendous pressure on these people
to conform and do stuff they don't particularly want to do. The government
must support the film industry, [*impassioned*] in every way that they can, the
talent is there. Then other people say, 'Australia has got no history, it's never
been blooded'. Tell that to the Aborigines, they've been blooded. There is a
history and it's got nothing to do with America and it hasn't got a great deal
to do with the United Kingdom any more.
What was your experience of the shoot with Polly?
She was wonderful [*enthuses*]. I showed her the whole studio but she just
chose a piece of wall! Then she took about 500 photos, I've never been
through such an ordeal! I just know that by posing for her she is good. I've
never worked so hard in all my life doing nothing!

Patricia Hewitt
MP, Minister for Small Business and e-commerce

Born in Canberra, 1948. Patricia Hewitt was educated at Canberra Girls
Grammar School and at Cambridge University. Elected MP for Leicester
West in 1997, now Minister for Small Business and e-commerce.
Her previous ministerial post was as Economic Secretary at the
Treasury (1998-9). Hewitt was Press and Broadcasting Officer (1983-7)
and Policy Co-ordinator (1987-9), to the then Leader of the Opposition,
the Rt Hon. Neil Kinnock; and Deputy Director (1989-94) of the
Institute for Public Policy Research. She has also served as Deputy
Chair of the Commission for Social Justice (1992-4) and as Director
of Research for Andersen Consulting (1994-7).

Do you feel Australian?

The longer I live here, the more I feel European – as well as British as well as
Australian. I represent a constituency with a large British-Asian population;
there are families who have deep roots in both countries, so I think I identify
quite strongly with that. I grew up in Canberra in the 1950s, and my grand-
mother, who had come out from England before the First World War, was still
in many ways very English, including her accent, and the way she gardened.
She had the most gorgeous English garden in Red Hill in Canberra. Looking
back on my childhood in Australia, it made me realise I really grew up British
in Australia, at a time when a large part of what we studied in primary school
was English history, we read English books, and played English Monopoly. So
the streets of London were more familiar to me than those of Sydney or
Melbourne.

*Are there specific aspects of what you've done, or the way you've done them,
that are Australian?*

When I was at Cambridge as a student in the late 1960s, it was noticeable that
there were a lot of us non-Brits who were active in student causes and were
challenging the way things were done. Then when I went to work for Age
Concern, then to run Liberty, Des Wilson was running Shelter, and Peter Hain
was running the anti-apartheid movement. So there were a lot of ex-colonials
who had come back to Britain and were saying: 'Look, this isn't right'. I felt very
strongly that Britain, home of the Magna Carta, the country which had helped
to give human rights standards to the rest of the world, was not living up to
those standards itself. At that time you'd hear people quite regularly on the
radio complaining about 'those foreigners coming back here to tell us what we
should be doing!'. I used to feel like saying, 'Hang on a minute, you came out

to Australia, New Zealand, to America and South Africa, and created white,
European communities in those countries and now we're coming back and
saying, 'Well actually, we think there are some things you could do better'.

Can you compare the politics of the two countries?

During the long, long years when Labour was out of power in Britain, the ALP
was in power both federally and in most of the states in Australia. So we
watched with incredible envy as Labor did all kinds of exciting things in
Australia, and we learnt a lot from the Australian Labor Party, both federally
and at the state level, and had a lot of exchange. And now they're looking to
us. The exchanges continue. Australia has changed quite extraordinarily. I
grew up in the days of White Australia and now I think it is the world's first
Eurasian country even though it may not use that phrase about itself. Australia
is a very vibrant and exciting multicultural country and there it is in the Asian-
Pacific region which is likely, because of China, to be the dominant economic
region of the twenty-first century.

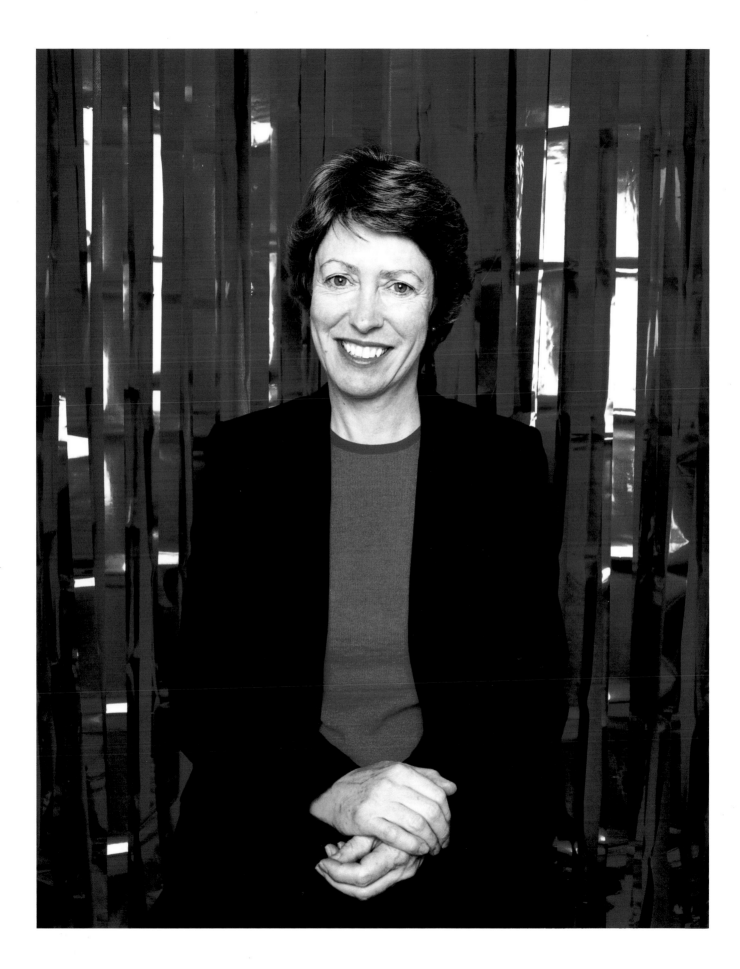

Dame Bridget Ogilvie ScD
Biologist

Born in New England, New South Wales, 1938. After completing a
Bachelor of Rural Science at the University of Armidale (NSW),
Dame Bridget left Australia in 1960 as a Commonwealth Scholar.
She qualified as a Doctor of Philosophy at the University of Cambridge
in 1964 and Doctor of Science in 1981 and became an Ian McMaster
Fellow at the CSIRO division of Animal Health in Australia (1971-2).
She worked as a laboratory scientist for the UK Medical Research
Council from 1963 to 1980, then joined the Wellcome Trust in the
UK in 1979 to co-ordinate the Tropical Medicine Programme, rising
to become their Director of Science Programmes in 1989. From 1991
to 1998 Dame Bridget was the Director of the Wellcome Trust.
Internationally bestowed with many honorary degrees, she was
awarded a DBE in 1997.

Did you intend to stay in the UK?

No. I tried to go back to Australia a couple of times, actually, but male chau-
vinism drove me away. It was impossible for women to make progress in those
days in the academic world. My dear father always said that we have to
remember that Australia was very close to its pioneering roots in my day and
it was really a reflection of that. But I have no bitterness about it. I've done very
well [laughs delightfully].

Why has the UK been more accepting?

I think it's partly because I chose by accident fields of academia that were new
and developing and women do well under those circumstances. Everybody
starts from scratch, everybody's on a level pegging. And I think if you're lucky
enough to do that, then you do well. I am a biologist and I was studying the
immune response to infection. It's a relatively modern thing, which probably
began in the 1960s, when I was a postgraduate. I think I've been extraordinarily
lucky, but I've capitalised on that luck! And I've been prepared to take risks.

What has been your experience of being an Australian here?

It's a huge advantage to be an outsider. Huge! I've always thought how
strange it is in this class-ridden country, that they are totally accepting of out-
siders; they accept you at your own valuation. I think we also don't give a
damn about the system! And so we all do very nicely, thank you. The curious
thing is that both countries have changed enormously. They've actually grown
closer together, because Australia has become so much more sophisticated,
and Britain has relaxed. When I think of what Australia was like when I was a
kid, drinking wine was regarded as bizarre. And as they used to say, it's not
possible for women to cook well, because the men cover the first course with
tomato sauce and the second with custard! And now you read all these articles
about the magnificent food on the Pacific rim! I've never lost the feeling of
being Australian, I guess I will always be suspended in the Indian Ocean. I
think you always vote for your country of origin. You look at the recent elections
[referendum vote] with amazement and enjoy the rugby [laughs wildly].

Have the English changed their attitude to Australians?

They've changed, just as Australians have changed. I always felt that when
Britain gave up its colonies, it was as if they all gave a great sigh of relief and
said 'Thank God that's over, now we can relax and be friends.' I think that was
a really seminal thing.

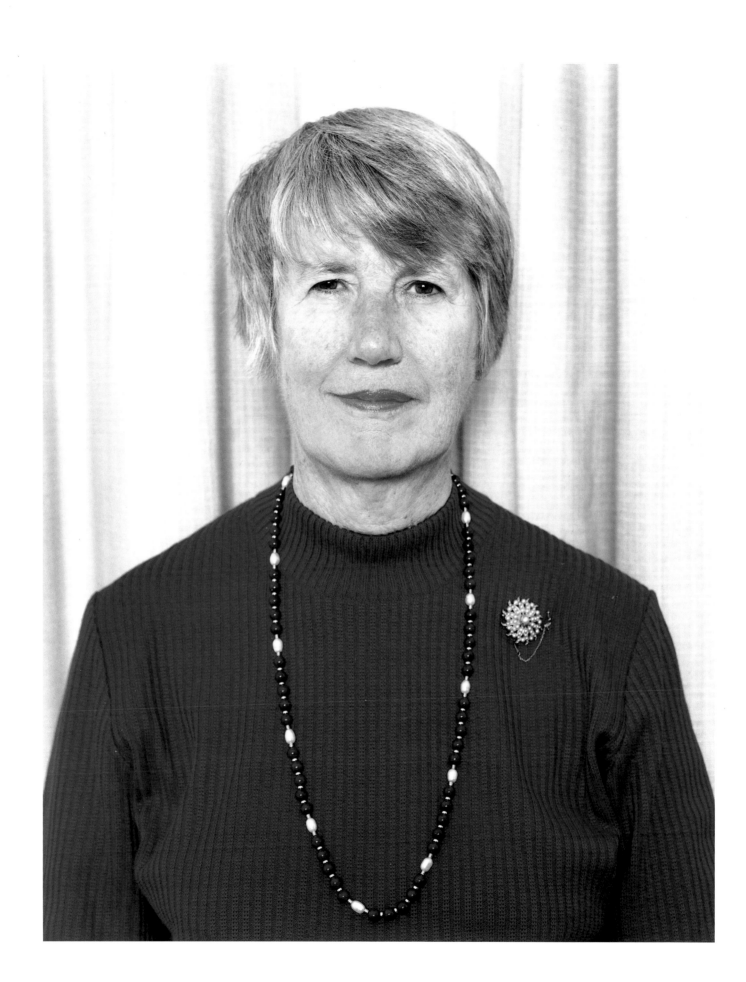

Baroness Gardner of Parkes
A Deputy Speaker of the House of Lords

Born in Parkes, New South Wales, 1927. After graduating in Dentistry
at Sydney University (1954), Baroness Gardner gained a Diplôme de
Cordon Bleu de Paris (1956). She practised dentistry with her husband
in London, retiring in 1990 to become Vice-Chairman of the North-East
Thames Regional Health Authority (1990-94), then Chairman of the
Royal Free Hospital Trust (1994-7). From 1982 to 1988 she was the UK
representative on the UN Status of Women Commission and she has
been Chairman of PLAN Intl UK (a children's charity) since 1990.
Baroness Gardner was Councillor of the City of Westminster (1968-78)
and elected to the Greater London Council (1970-73, 1977-86).
Elevated to the Peerage as a Life Peer in 1981, she was appointed a
Deputy Speaker of the House of Lords in 1999.

What are your views on the changes in the House of Lords?
I view it as personally sad and as constitutionally unsatisfactory; it would have
been better to have put through the reforms as a complete process, rather
than abolishing the hereditary peers with no one knowing what will follow.
What is the difference between politics in the UK and in Australia?
As I understand it, the Australian Senate can hold up financial bills which we
can't do here. That power [to block supply] was lost to the House of Lords in
1911. The language that's acceptable in Australian parliament is much more
abusive. Words like 'scumbag' and 'liar' would not be acceptable here.
How did the House of Lords react to you as an Australian?
When I first went into the Lords, people found me very outspoken and it has
taken time for them to accept that [smiles]. I don't think they've ever required
me to change but there has been a degree of adjustment from both sides. If
you were outspoken to the point of rudeness that would not be acceptable in
the Lords at all but people do like you to be frank and open. If anyone tried to
identify me in the House, they would just say 'That Australian woman'. Some
people have also referred to me as 'That floral lady', because of the title. In the
House of Lords there are only two dentists, myself and a hereditary peer. And
I'm the only Australian woman that's ever been in the House of Lords. It makes
you feel very humble to be a part of it. If someone had said to me you would
become a member of the House of Lords I would really have found it totally
unbelievable.
What is your view of Australia now?
I have an Australian passport only and I have never considered applying for
British citizenship. My family were Australian pioneers and I really value my
Australian nationality. I think Australia will eventually become a republic, but

the links would be broken between the two countries only in the constitutional
and parliamentary sense. The fondness for the present Queen and Queen
Mother will continue. It's become a multi-racial country but I don't welcome
that if it leads to ghettoisation of groups. I believe Australia will become a dif-
ferent country when you get a fully mixed nation and this process takes time.
Australia needs to be like America where there is an amalgam of different
groups of people.
How was the shoot with Polly?
It was fascinating. There was a Judicial Sitting of the House of Lords, so there
was no Line of Route, no passing visitors, which meant we were uninterrupted.
The photo was taken in the Queen's Robing Room, with its ornate Pugin dec-
oration. My robes are desirably second-hand, as they shouldn't look too new.
The one time of the year I wear them is for the State Opening of Parliament.
Polly arranged the robes so beautifully – the portrait was clearly going to be
more like a painting.

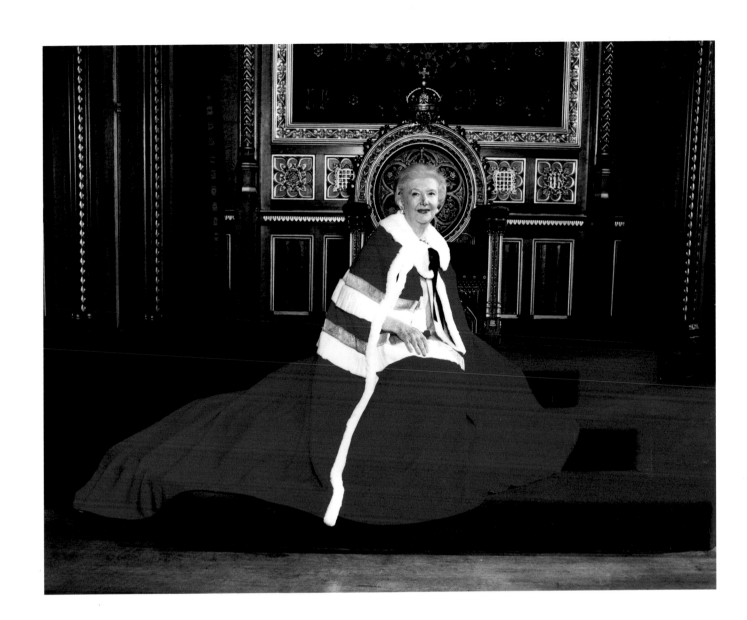

Sir Les Patterson
Cultural Attaché to the Court of St James, aka Barry Humphries

Born in Sydney, Lesley Colin Patterson left Our Lady of Dolours School at fourteen and after a stint as a cinema usher became Entertainments Officer at a Sydney football club. His showbusiness experience and labour political connections secured him favours from the charismatic Whitlam administration, securing him the appointment as Australia's first Cultural Attaché to the Court of St James in 1974.

Sir Les was knighted by The Queen for his services to Australian culture, and awarded an honorary doctorate in Australian Studies by the University of Cambridge. In spite of his popularity with the British Royal Family, Sir Les, true to his Irish-Catholic roots, is an avid Republican and was a highly rated candidate for the Australian Presidency, where his diplomatic credentials and media popularity gave him the advantage over less appetising candidates. He is a member of the Sydney Institute and sits regularly on the Australian Cheese Board, being a world authority on Tasmanian Camembert. He is now one of the movers and shakers behind the scenes of the Sydney Olympics.

He has released an album of urban folk songs, *Twelve Inches of Les*, and is author of a best-selling manual for dipomats, *The Traveler's Tool* (revised edition *The Enlarged and Extended Tool*). He recently made a sensitive sex education video for schools and church organisations entitled *Les Patterson has a Stand Up*.

Mine is a sedentary job; I've always been a mover and shaker and in this photograph, I'm doing both.

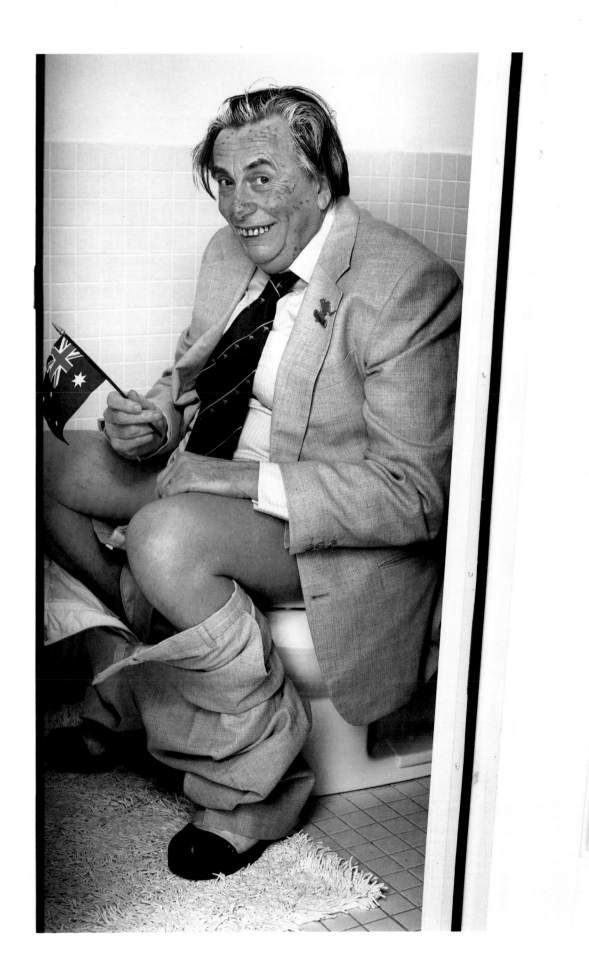

Peter Tatchell
Queer and Human Rights Activist

Born in Melbourne, 1952. Peter Tatchell began campaigning for gay
freedom in 1969, aged seventeen. On moving to London in 1971,
he became a leading activist in the Gay Liberation Front (GLF),
campaigning to end the medical profession's classification of
homosexuality as a 'mental illness'. Two years later, in East Berlin,
he was arrested and interrogated by the secret police, the Stasi,
after staging the first ever gay rights protest in a communist country.
He was the defeated Labour candidate in the 1983 Bermondsey
by-election – proclaimed by Tatchell as the most violent and
homophobic election in British history. In 1987 Tatchell launched
the world's first organisation dedicated to campaigning for the
human rights of people with HIV, the UK AIDS Vigil Organisation.
He co-founded the queer rights direct-action group *OutRage!* in 1990.
Most notoriously, in 1994 he named ten Church of England bishops
and called on them to 'tell the truth' about their sexuality – accusing
them of hypocrisy and homophobia. This lead to him being denounced
by the press as a 'homosexual terrorist'.

What does being Australian mean to you?

Much to my regret, I was stripped of my Australian citizenship when I became
a British citizen. It was a big shock because I thought I could have dual nation-
ality. Nevertheless, I still feel Australian. Much of my direct action style of pol-
itics is a continuation of the methods we used in the 1960s to campaign
against conscription and the war in Vietnam. My inspirations – then and now
– are the non-violent, civil disobedience politics of Mahatma Gandhi, the
Suffragettes and Martin Luther King.

Is there something about Britain that has allowed your campaigning to flourish?

One of the reasons I've been a successful campaigner for queer rights in
Britain is because I'm not British. My rebellious, independent-minded spirit,
which comes directly from the Australian radical tradition of the 1960s, has
enabled me to carve out a unique place in British culture and politics. Most
Brits don't dare say the things I do. Deference to authority, emotional reserve
and the stiff upper-lip mentality still runs deep in the national psyche. Many
people thought my interruption of the Archbishop of Canterbury's Easter ser-
mon in 1998 was scandalous, but the real scandal is the Archbishop's advo-
cacy of discrimination against queers. Although I've made my home in Britain,
I still feel an outsider. I don't conform to the expectation of how human rights
campaigners are supposed to behave. Because of my refusal to conform to
the rules of conventional politics, the snobbish, hide-bound British establish-
ment loathe me. The feeling is mutual [*smiling*].

What is your view of Australia now?

The awful suffocating conservatism of the Menzies era seems like a lifetime
ago. There are still, of course, some reactionary strands in Australian politics.
But nowadays, by comparison to Britain, 'Down Under' is in many respects

more liberal-minded – especially with regard to the celebration of queer cul-
ture, as exemplified by the huge public profile and popularity of Sydney's Gay
and Lesbian Mardi Gras. Much of Australia now runs rings around the reac-
tionary, homophobic 'mother country' [Britain].

What was the idea for the shoot with Polly?

The replica of a police mugshot was an attempt to convey my thirty-plus years
of defying unjust, homophobic laws. I've been involved in over a thousand
non-violent civil disobedience protests, often getting arrested. In late 1999, I
was prosecuted for my citizen's arrest of President Mugabe of Zimbabwe. His
government has committed acts of torture, which are illegal under British and
international law. I was trying to apprehend Mugabe on charges of torture. But
instead of arresting him, the police arrested me. This photo symbolises the
State repression that is often used against human rights activists who chal-
lenge injustice and tyranny.

PETER GARY TATCHELL
QUEER TERRORIST
NO: 01AB4007199
BELGRAVIA POLICE STATION
SEPT 30 1999

Geoffrey Robertson QC
Barrister, Broadcaster, Author

After graduating with a BA (1966) and LLB Hons (1970) from the
University of Sydney, Robertson attended University College, Oxford as
a Rhodes Scholar. In 1973 he was called to the Bar, Middle Temple,
where he became a Bencher in 1997. A civil liberties specialist and
Head of Doughty Street Chambers since 1990, he was Visiting
Fellow at the University of NSW in 1977 and has been Visiting Professor
at Birkbeck College, London University since 1997. A broadcaster and
author, Robertson has appeared as the Moderator in the television
series *Hypotheticals* since 1981.

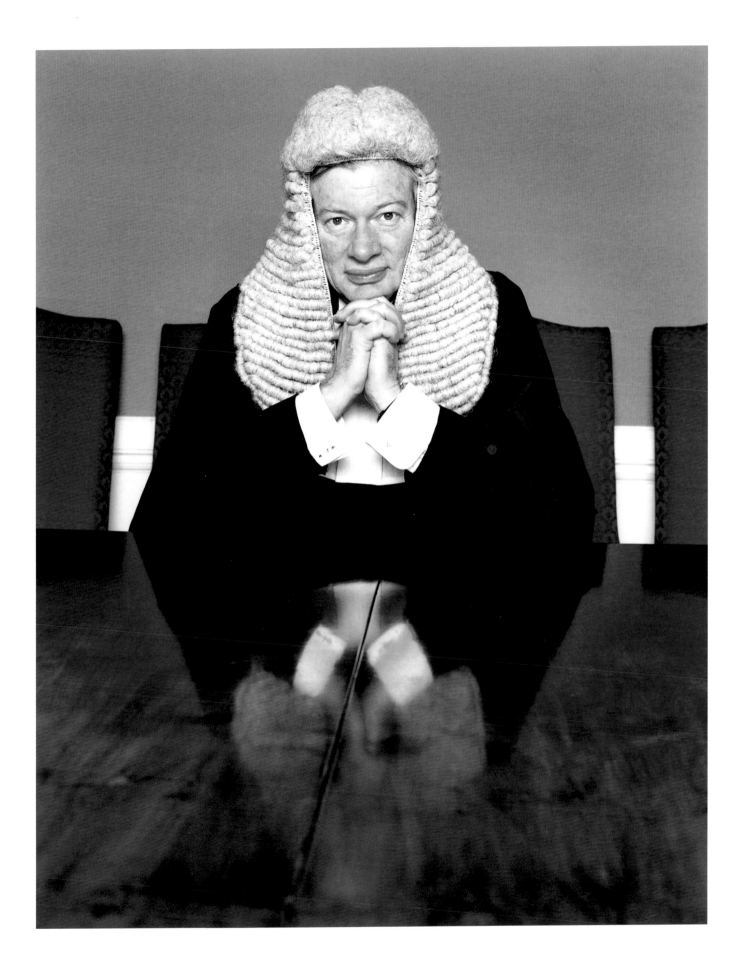

Rolf Harris MBE, OBE
TV Presenter, Entertainer

Born in Perth, 1930. National Junior backstroke champion aged fifteen,
Rolf Harris qualified as a teacher before he left Perth in 1952 to study
art in the UK. His television career began in London in 1953 as a
cartoonist-storyteller, and he went on to present the BBC's *Rolf Harris
Show* (1967-71), and *Rolf's Cartoon Club*, which ran for six series until
1993. Harris's song *Tie Me Kangaroo Down, Sport* became a number
one hit in Australia and the UK (1960-61). *Sun Arise* and *Two Little Boys*
also topped the charts and *Stairway to Heaven* (1992) went to number
four in the UK. Since 1995 he has presented the multi-award-winning
Animal Hospital television series. A writer of books on cats, music and
cartoons, Harris performs regularly in concerts and TV specials around
the world. He has been awarded an MBE, an OBE, and is a Member of
the Order of Australia.

What does it mean to you to be Australian?
You know you can tackle anything because that's part of your upbringing. You
are always given the opportunity to do things for yourself. For example, when
using tools as a kid, Dad always explained the problems and said 'Be careful
you don't cut yourself, always make sure your hand's out of the road if you're
using a chisel', but then he said, 'Off you go, if there's any trouble, give us a
yell'. So we were given confidence in our ability to tackle anything. You just
have to do your homework – find out *how* to do it, but you know you *can* do
it. That's the way we grew up. Very free and easy.
How would you describe your experience of being an Australian in the UK?
At first I was busy trying to be British, trying to conform to fit in with everybody
else. Then I had my first record, a number one hit, *Tie Me Kangaroo Down,
Sport*, singing in my own unashamedly Australian accent and I remember
thinking, 'Well that's a shock, I can actually be myself, be Australian *and* be a
success!'. I came back [to the UK] a couple of years later, armed with that
knowledge and suddenly I wasn't busy trying to pretend to be somebody else.
It made such a difference.
What's your view of Australia now?
It's got every chance of continuing to be as amazing as it always has been.
[But] I think we've got to come to grips with ecology a little bit more. We've got
to stop covering the country with concrete and try to live within the country,
rather than try and impose our will upon the country. Don't use the resources
up as if there's a never-ending supply.
What do you recall of the shoot with Polly?
We came out to my house and we did *Jake the Peg* in various different posi-
tions. Lovely [*chuckles warmly*]. *Jake the Peg* was a landmark in my career.

There are lots of laughs in the song. I was dressed up as a three-legged man
and we were trying to find different ways in which it would look funny or good
or interesting, how we could do it without giving the game away too much as
to how it was done.
Good Aussie innuendo?
There's no innuendo at all [*offended*]. There are no double meanings at all. It's a
lovely bit of innocent comedy really. It's just a very devil-may-care Aussie attitude.

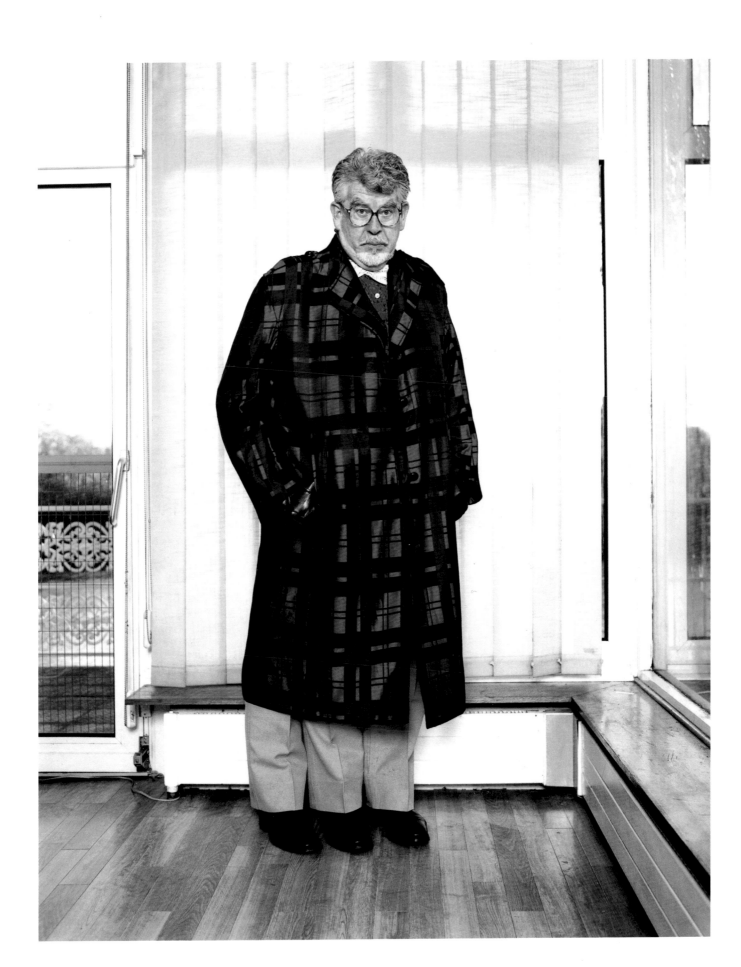

Sir Charles Mackerras AC, CBE
Conductor

Born in the USA, 1925. Sir Charles Mackerras studied in Sydney and
Prague and made his debut as an opera conductor at Sadler's Wells
(later the English National Opera), where he was Musical Director
(1970-77). From 1976 to 1979 he was Chief Conductor of the Sydney
Symphony Orchestra and conducted the opening public concert at the
Sydney Opera House. Sir Charles continues to appear with orchestras
and opera companies worldwide and is currently the Conductor
Laureate of the Scottish Chamber Orchestra, Conductor Emeritus of
Welsh National Opera and Music Director of the orchestra of St Luke's,
New York. His extensive discography has attracted many international
awards. He was knighted in 1979 for his services to music and in 1997
he received a Companion of the Order of Australia.

Did you find that people reacted differently to you when you first came here?
I left Australia in 1947, and don't forget, at that time in Australia there wasn't
really much you could do as a musician to broaden your horizons. You really
had to go abroad in my view, you still have to. Europe has been the basis of
musical culture throughout the centuries and in order to be able to experience
the ground repertoire of classical music, you have to have seen Europe. Music
written in Australia over the past fifty years definitely has an Australian tinge.
The other arts have been intensely Australian for much longer, because, for
example, if you're painting the Australian scene, it has always looked com-
pletely different from anything else in the world.
How does the music sound distinctively Australian?
When it is representative, for example Sculthorpe's Sun Music conjures up the
atmosphere and nature of Australia. Sculthorpe founded what you might call an
Australian style in music, which has influenced future Australian composers.
What is your view of Australia now?
Having got rid of the British image and taken on the American image, it now
seems to have got rid of that one too [laughs]... I think it's managed to shed
some of those images because of its position, being so far away from both
Europe and America. I think Australia should keep away from the attempt at
globalisation by America of everything, a cause of the recent terrible riots in
Seattle. However, I fear it may be too late.
What is it about the UK that has kept you here and allowed your career to flour-
ish, other than being close to European music?
That's really it. I lived for a short time in Germany, but London is not only a
wonderful centre for music itself, it's a good springboard for both Europe and
America. For a freelance musician, London is the best place in the world to live.

Do the British embrace music more than Australians?
Yes, but unfortunately it's taking on this worship of popular culture, which
makes performance and production of classical music more difficult.
Because the pop world is so vast and so greedy for profits, the classical world,
which interests a minority of people, is apt to get swamped.
How was the photo conceived?
Polly asked me to wear tails. Whenever I go to a photographic session, I ask
what they want me to wear, whether formal or informal. When she wanted me
in tails, I assumed she wanted formal photographs, so I was rather surprised
that she chose to take all the photos in a bedroom. I am looking forward to
seeing how it turns out.
Did you have your baton?
I can't remember.

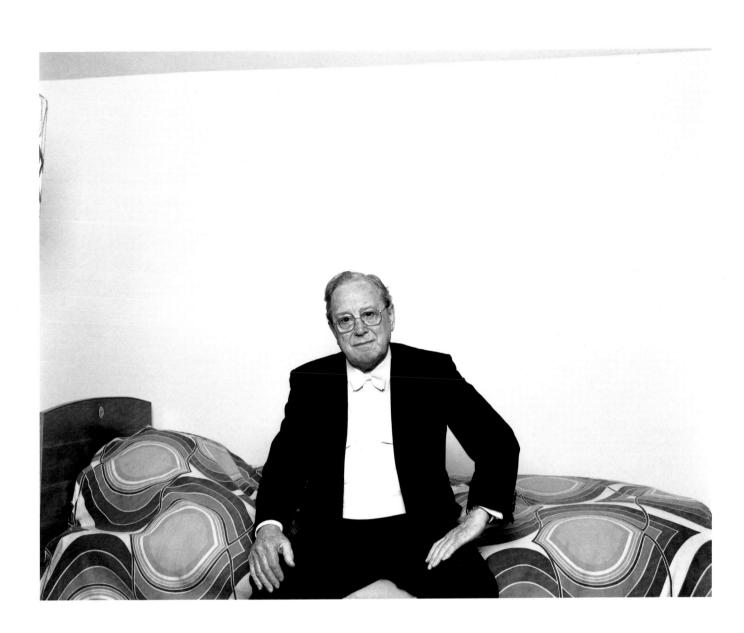

Bill Muirhead
Advertising Executive, Founding Partner M&C Saatchi

Born in Adelaide, South Australia, 1946. Bill Muirhead moved to London
in the 1960s. He studied marketing and in 1967 he went to work for
the Sydney-based agency Jackson Wain. He joined Ogilvy & Mather in
London (1969-71), then Saatchi & Saatchi (1971-94), handling key
accounts such as British Airways and the Conservative Party
(1992 election). Muirhead became Chairman and Chief Executive Officer
of the London agency in 1988 and Chairman and Chief Executive of
Saatchi & Saatchi Europe in 1992. He moved to New York in February
1994 as Chief Executive Officer of Saatchi & Saatchi North America
and became President of Saatchi & Saatchi Worldwide. In January 1995
he became a founding partner of M&C Saatchi in London.

What are the differences between the UK and Australia?
People leave Britain when they can't make it here. People leave Australia
when they want to make it somewhere bigger. In the 1970s and 1980s,
Australians did particularly well here, maybe because the English didn't know
what suburbs we came from. We were a sort of classless group and could
get away with a lot more than our English counterparts. I love it here. London
is a great city and England is a very creative and extremely tolerant place. It's
not corrupt, but sometimes I think the English are too self-critical. When
Maurice Saatchi went to Australia for the first time in 1995, he couldn't get
over how happy and optimistic the people were. It feels so fresh and young.
Of course the British send us up as well. We're convicts, and we're uncouth,
a bit brash. But they think we're all brilliant at sport. That's worth a game or
two in a tennis match.
Is the traditional image dying out?
I think the 'ocker' image is fading away. I think this is best summed up by the
change in the Fosters lager advertising. Fifteen years ago, we had Paul Hogan
(an urban Australian) over here taking the piss out of the Poms. Today,
Australians are distinguished by their positive, laid-back attitiude. Now the
Fosters advertising line is 'He who thinks Australian, drinks Australian'. So,
non-Australians can become 'honorary' Australians – only if they drink Fosters,
of course.
Do you still see yourself as Australian?
Absolutely. When I went to the Rugby World Cup [November 1999] in Cardiff,
I became very emotional. It's a terrible thing to admit, but I cried when they
played Men at Work's Do you come from a Land Down-Under? It was so mov-
ing and made me feel really good. Very proud. I hope to be buried in Kapunda,

about sixty miles north of Adelaide. It's where I come from and I still love it,
I really do. Every time I try to go back [to live], something happens and I can't.
I've always thought I would just be here temporarily.
What do you hate about being an Australian here?
I loathe the fact I can't get meat pies.
Are you aware of a duty of being an ambassador for your country?
I'm always conscious of that. I still try to help promote Australia as much as I can.
What do you think you have given the UK?
An awful lot of income tax!

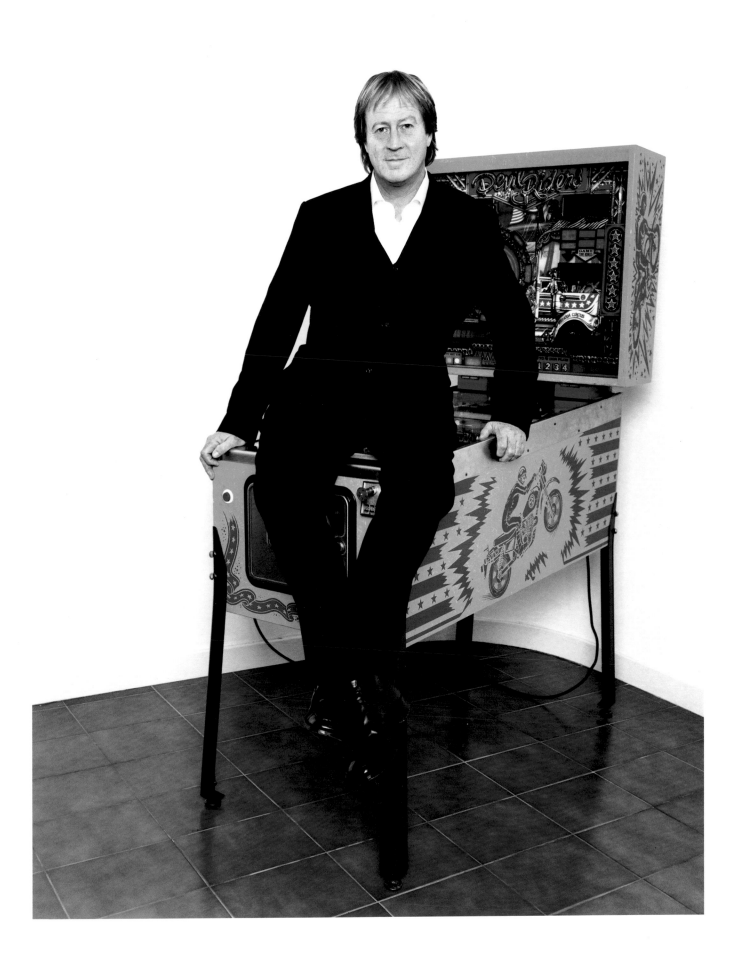

Barrington Pheloung
Film and Television Composer

Born in Sydney, 1954. Barrington Pheloung moved to the UK in 1973 to study at the Royal College of Music, where in 1995 he was appointed Professor of Composition. He became Musical Advisor to the London Contemporary Dance Theatre (1979-90). Pheloung composed his first TV score for *Boon* (1985), then for *Inspector Morse* (1986-2000). His *Morse* score reached number four in the UK album charts. Pheloung has composed fifty-two ballet scores and writes regularly for television. He has composed many concertos for guitar, cello and double bass, and performs regularly as a guitarist and conductor. His soundtrack to the film *Hilary and Jackie* reached number six in the US Billboard charts and was nominated for a BAFTA award. Pheloung composed the link music for the midnight show at the Millennium Dome on New Year's Eve 1999, which was seen by two billion viewers worldwide.

What defines you as an Australian?

Like all Australians, I'm always very proud of our sporting achievements. I've always been a complete cricket fanatic. That's about the most nationalistic I become. But I do support the English cricket team when they're not playing Australia. The love for the sun, the surf, and the bush. I love the ruggedness of the Australian bush, the untameability of it. I hope Australia will not change too much anymore. It's one of the fairest and most democratic countries in the world and one that has stuffed up the planet less than most. Though I would like to see the complete cessation of any deforestation. I won't be able to live in Australia until my boys are older. But as far as my career is concerned, it doesn't really matter where I'm based. In this day and age you can work anywhere. If Nigel Kennedy wanted me to write a violin concerto for him, I would just write it in Australia, in a studio overlooking the Pacific Ocean and the bush [*laughs*]. There is an openness, a breadth, that I am sure creeps into my psyche or spirit – it certainly gets into my writing. I still physically yearn to be there. Under a gum tree!

What has been your experience of being an Australian in the UK?

It's changed a lot in twenty years. There is so much Australian culture pervading the world now. In the 1970s it was still Barry McKenzie days – Australians were all considered to be cork-hat wearers, and the English were always astounded if you knew any Latin. I've fought hard all through my career not to be pigeon-holed. I've always attempted to stay in touch with the more universal nature of my own very catholic music tastes. Classical, jazz, blues, techno, folk, pop – whatever, as long as it's sincere. In the past however, especially in England, these different styles have been mutually exclusive. Perhaps that has been a class thing. Musically, there has always has been a disproportionate amount of talent coming out of Australia. I don't think there is an orchestra in the world that I've conducted that doesn't include a prominent Australian player in it, and there's probably no ballet company in the world that hasn't got an Australian in the corps de ballet or a principal. Perhaps there wouldn't be the same opportunities in Australia for me as a composer or as a conductor. London is the music capital of the world, there's no question about that. But I would just love to live and work in Australia. I've done hundreds of film scores, but never an Aussie one. It's 'Barrington Who?' over there. I can't get a bite back home; it could be that, with a name like mine, they assume I'm a Pom!

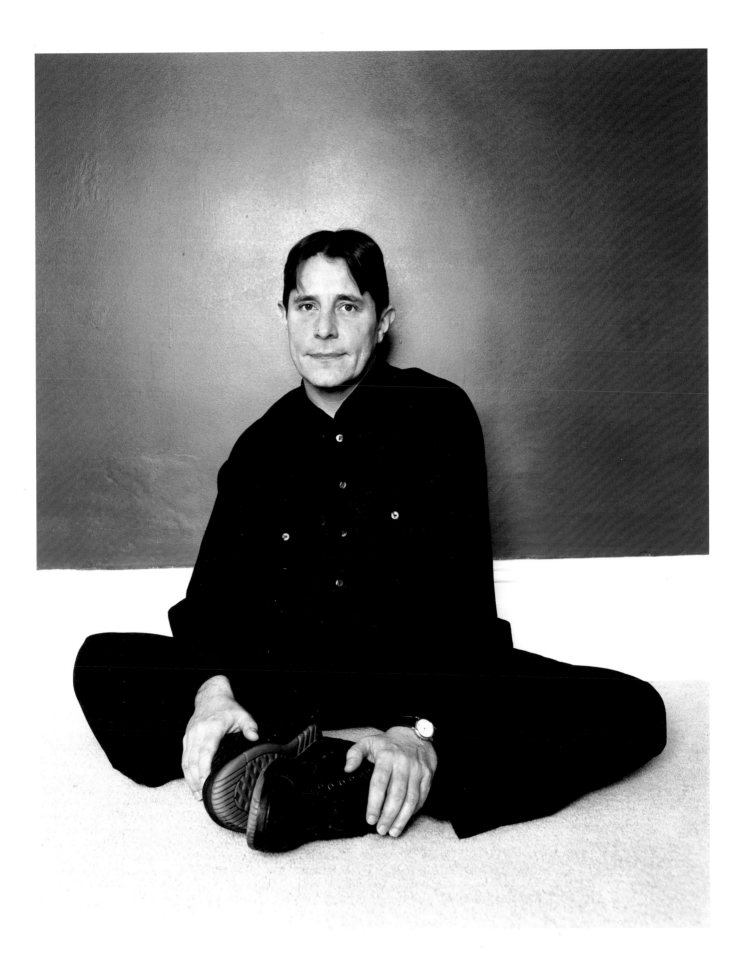

Michael Blakemore
Theatre and Film Director

Born in Sydney, 1939. After studying medicine at Sydney University, Blakemore became a press agent to Robert Morley. He travelled to London to study at RADA (1950-2), then worked as an actor and director for provincial theatre companies. He joined London's National Theatre as an associate director, directing Laurence Olivier in *Long Day's Journey Into Night*. Blakemore's books include *Next Season* (1967) and film credits include *A Country Life* (1995) and *A Personal History of the Australian Surf* (1981). Broadway musicals include *City of Angels* (1990) and *The Life* (1997) both of which received Tony nominations. On Broadway he has just directed the musical *Kiss Me Kate* and is currently at work on *Copenhagen*.

What is your experience of leaving Australia for the UK?

When I was starting out, you really had to make that trip to England, if only to lay a few ghosts to rest. In Australia we lived in a copycat society that looked to Britain for everything – institutions and cultural sustenance. It's different now and the Australian theatre often offers strikingly original work. However, the problem of population size remains. Without enough people to provide that much smaller sub-group who support the arts, it is very difficult to build a tradition with any certainty of continuity. And this is discouraging to anyone hoping to earn a living in the arts locally. Australia has always been tough on its talent. And it is certainly ambiguous about its expatriates. I've had more hostile or indifferent reviews in Australia than anywhere else in the world. It's odd, because at one time the English attitude to Australia was extremely patronising and merited resentment, but now it's positively benevolent. Australia is the place that the Brits long to visit because they see it as much like home, plus endless sunshine and prawns. But of course, there is a sting in the tail. Australia's hedonistic advantages can never quite compensate for the complexity and sheer density of European life. There is such a thing as a prawn too far. Maybe that is what has kept me here. Although I've never felt anything other than Australian.

How would you describe your passion for the surf?

It's a metaphor for liberty, a sport that's playful, not competitive. Surfing is playing with the ocean, and you can't do that in the Thames.

How would you describe the quintessential image of Australia now?

It has changed, but the colonial schizophrenia lingers. It used to be defined by two quite different sorts of Australians. There was that discontented minority who went questing around the world, or, if they stayed, stayed to rock the boat.

These are the people who, for good or ill, defined the country for the rest of the world. Then there was their natural enemy – that great rump of incurious and aggressively parochial Australia. That is why we left, because we had this feeling that the really interesting things were happening elsewhere, that we were missing out on the party. It's the jumbo jet that has changed things. Australia has learnt to throw a party of her own, and most of her citizens, I'm glad to say, are taking up the invitation.

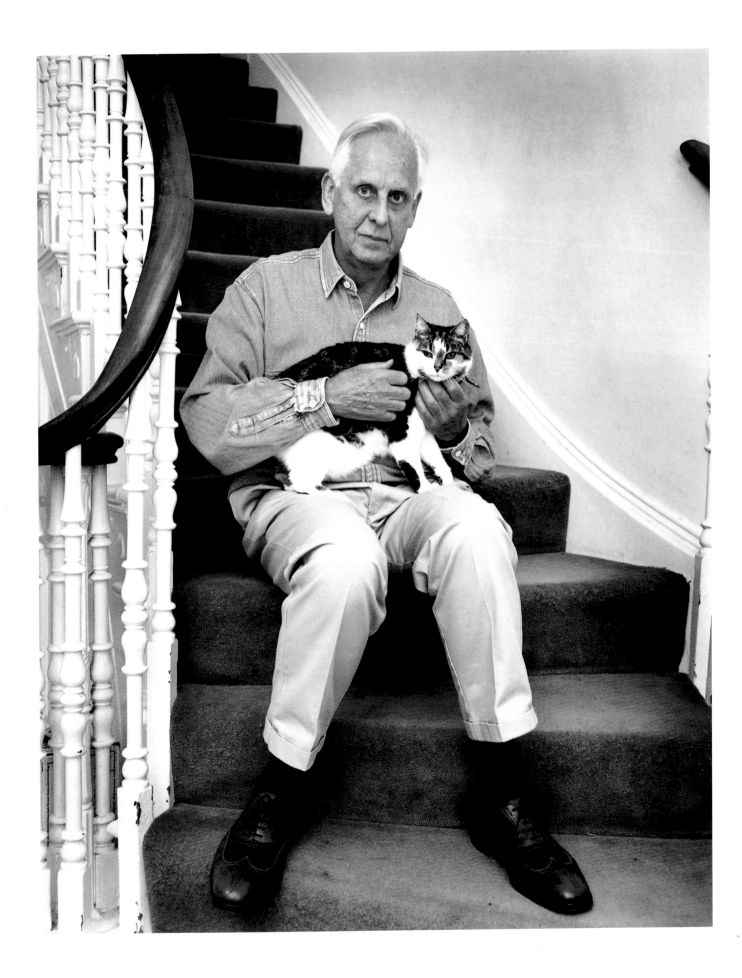

John Williams
Classical Guitarist

Born in Melbourne, 1941. John Williams was taught the guitar by
his father, and he went on to study at the Academia Musicale Chigiana
in Siena, Italy, and at the Royal College of Music in London.
He has performed worldwide, playing both solo and with orchestra
and appears regularly on radio and television. He has collaborated
with other musicians including Julian Bream, Itzhak Perlman,
Andre Previn, Cleo Laine and John Dankworth and with the groups
SKY, John Williams and Friends and Attacca. Williams has played
for films including *The Deerhunter* and *A Fish Called Wanda*. The highly
successful *Profile* and *The Seville Concert* are examples of his
enthusiasm for communicating music on television.

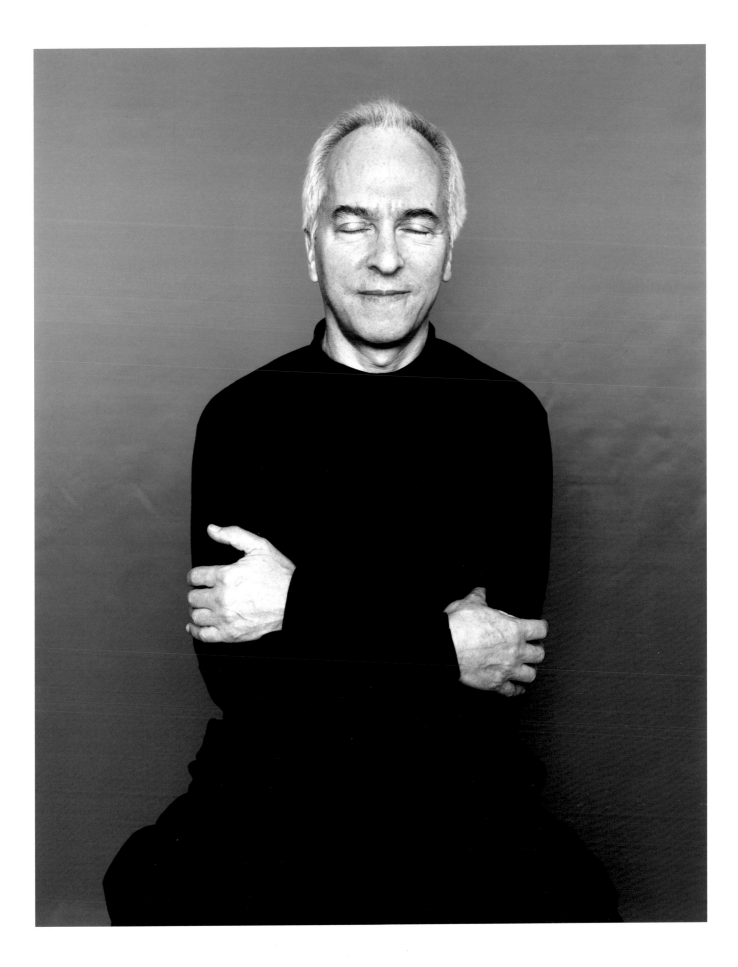

Toni Colette
Actress

Born in Sydney, 1972. After taking up a scholarship at the Australian
Theatre for Young People, Toni Colette studied at the National Institute
of Dramatic Art (1991-92). Her theatre credits include *Uncle Vanya*
(1992) and *King Lear* (1994) with the Sydney Theatre Company, and
FROGS with the Belvoir St Theatre. She has been honoured with many
awards, including a nomination for an Australian Film Industry award for
Best Supporting Actress, in *Spotswood* (1990), and a Golden Globe
award for Best Comedy Actress for *Muriel's Wedding* (1993). Other films
include *Velvet Goldmine* (1997), and *The Sixth Sense* (1998). She is due
to play Queenie this year in *The Wild Party*, a Broadway musical directed
by George C. Wolfe.

What did you think of the photographic session?

This shoot was unusual in that I have never actually been photographed just
as myself. More often than not, they are for glossy magazines and they try to
sell you as a certain type of image, it's pretty rare when they actually want you
to be seen as yourself.

What is your take on Australia?

The more time I spend away the more I realise how profoundly special that
place is. The last time I was home, there was a familiarity and a sense of ease
that was innate, that couldn't be taken away, and I really appreciated that – it
was really grounding. And there's a certain sense of irony which doesn't exist
in certain other cultures. Also, there is something to be said about the fact that
people stick to the coast, when there is so much space. It's like the strength
of the land is almost intimidating. People actually get afraid of going out into
the country. I mean what do you do with all that space? People are so used to
living like ants and when you're given all that space, there's something so
powerful.

Starting out in Australia as an actress, you do it because you want to do it.
All of the films that are made in Australia are independent films and there is no
studio system to contend with, where they want to prime people. It just shocks
me that, in other places, being on the cover of magazines and turning up at
the right parties is just as important as doing good work. In Australia it's almost
embarrassing to win awards or have any sort of acclaim. The UK pretty much
has the same sensibility. I feel really comfortable here. In terms of work
though, the Australian film industry isn't big enough to sustain any one career.
I would get bored as would the audiences, and you wouldn't be challenged
because it would become too much of the same.

The Olympics are putting on so much pressure. I was at home for Christmas
and I was embarrassed about the face-lift Sydney's getting. It's like everyone
is putting on their best Sunday clothes.

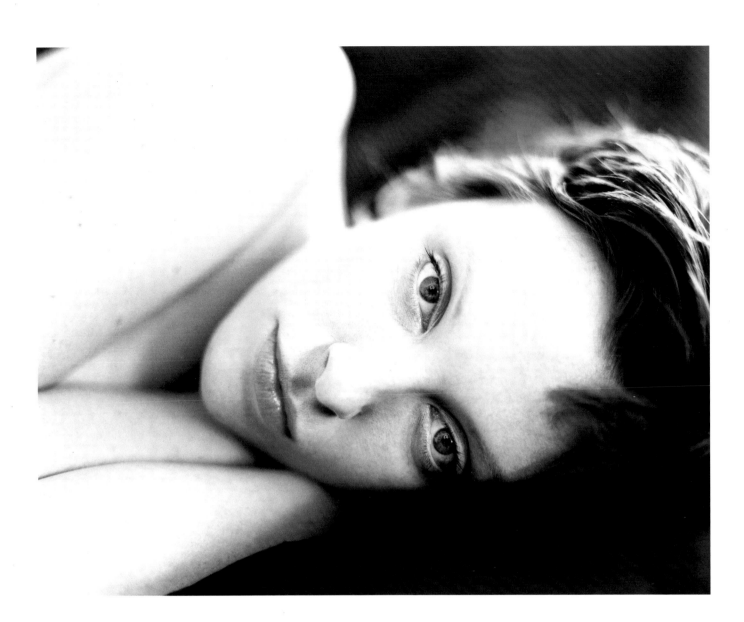

Professor Robert O'Neill AO, FASSA, FRHistS
Academic, War Historian and Strategist

Born in Melbourne, 1936. A graduate of the Royal Military College of Australia and member of the Australian Regular Army (1955-68), Professor O'Neill graduated in Engineering from the University of Melbourne in 1960. He won a Rhodes Scholarship to study at the University of Oxford, where he completed his doctorate in 1965. Professor O'Neill was Head of the Strategic and Defence Studies of the Australian National University (1971-82), then moved to London in 1982 as Director of the International Institute for Strategic Studies. In 1987 he became the Chichele Professor of the History of War at Oxford and a Fellow of All Souls College. The author of several books, Professor O'Neill's principal specialisation has been the problems of the Asian-Pacific region.

At the turn of the millennium, what changes are ahead?

I think the East Timor peace-keeping operation has been a defining moment. It's been a tremendous test of Australia's abilities to exert leadership and influence in its own region, when other powers were either jealous or just opposed to allowing Australia to do what it has done. We are not out of the woods yet, there will be some diplomatic costs to be paid. But I think the fact that our chaps went into East Timor, did the job competently, didn't let things get out of hand, with very little bloodshed, is very much to our credit. I was at the United Nations in November 1999 and heard much favourable comment from other people, including Americans, who are all the time looking for allies who can help rather than be dependent.

What is the potential then for Australia?

I think Australia will steadily become a more influential player in the south-east Asian and east Asian region, provided it plays its cards well. I'm very sure that our foreign service has a good grip on how to do things. The real uncertainties lie much more at the political level where people are coming in from outside, often with very little experience of foreign policy. They may seem to be secure, but in reality the world is still vulnerable. I was more worried about it thirty years ago that I am now. In an era of globalisation, with the United Nations upholding standards of international conduct and human rights, the world on the whole is a much more reassuring place to live in. Australia benefits from that, but it also means that Australia has to support the UN and be involved in commitments elsewhere. It doesn't end at that. We have to play our role in terms of helping education in the region, helping the flow of trade, ideas, people.

Is there any way of comparing the attitudes of the two countries to war?

I think that because the First and Second World Wars happened immediately adjacent to Britain, and fighting air attacks in both wars made a direct impact, there is more of a war consciousness in Britain and a desire to assert force as an early response to a challenge. I think Australians do not respond in a military sense as quickly as the British do, perhaps because Australia is insulated from international disasters. There is a British tendency to be tough with international aggressors, as one saw in the headlines of the *Sun* during the Falklands War: 'Biff the Argies!'. It would be hard to use that kind of sentiment to the same extent as a political platform in Australia.

How would you describe the quintessential Australian?

Outgoing, internationalist, pragmatic, well-informed. Still a little unsure of himself, by comparison with Europeans, but that gap is narrowing as European nationals become more confused about their self-identity.

Is your academic role reflected in the photograph?

I have a feeling that I'm detached from the environment. The focus is on me as an individual and not the props – I'm quite happy for it to be that way from time to time!

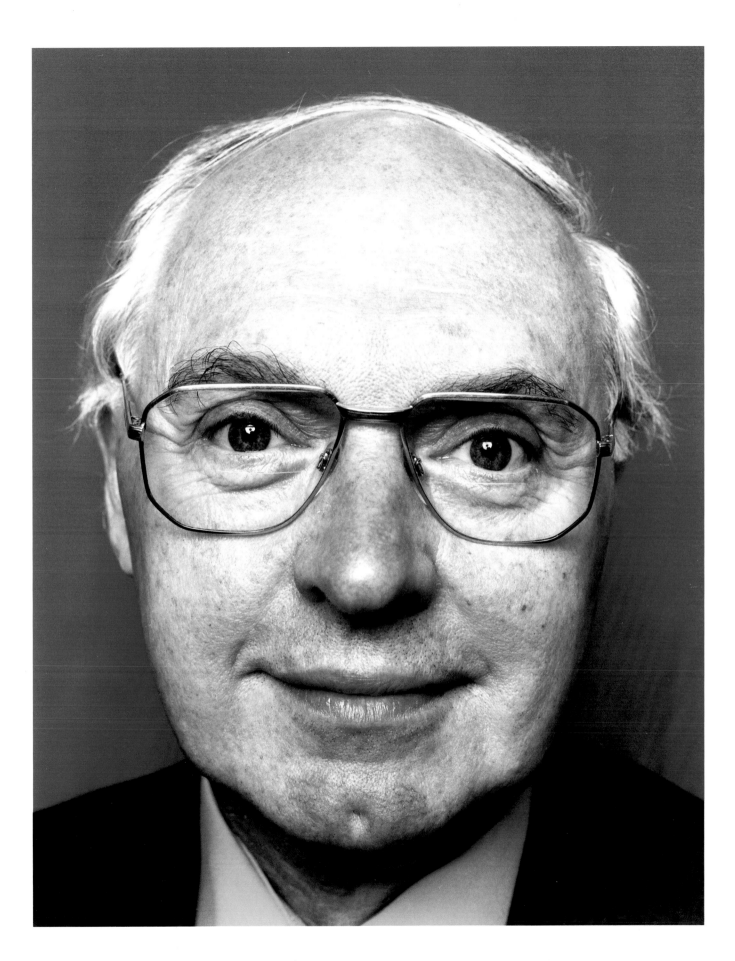

Peter Porter
Poet

Born in Brisbane, 1929. After working as a reporter on the *Brisbane Courier-Mail*, then as a warehouseman, Porter came to England in 1951. Employed as an advertising copywriter (1959-68), Porter's first book of poems, *Twice Bitten, Twice Bitten* (Scorpion Press) was published in 1961. Other publications include *The Lady and The Unicorn* (1975), *Collected Poems* (1983) and *Mars* (1988). Porter was the Writer-in-Residence at the Universities of Sydney, New England, Edinburgh, Melbourne and Western Australia from 1975 to 1987. He has also been Poetry Critic of the *Observer* (1973-90), Winner of the Whitbread Poetry Prize (1988) and the recipient of a Gold Medal from the Australian Literature Society (1990).

What is your experience of being an ex-pat?

There's a distinction between Australians who are good at something and come overseas, playing the horn, acting or playing tennis. Nobody at home has any objection to their doing that. But if creative artists, including painters, go overseas, they're always considered renegades, betraying their countries. I didn't see Australia for twenty years (1954-74), but when I went back there it had changed for the better, there was a lot of self-confidence in the arts.

As a country, it has got the right circumstances for producing artists. It's an edgy country, never completely at ease with itself. Australia's got a lot of interesting new writing going on. It has been world-class in painting for many years, writing has only now become world-class. For example, a writer like Peter Carey would be among the best novelists in the world, Les Murray is a world-class poet.

One of the faults I find in Australian poetry is that it's so dedicated to the idea of democracy without excluding anybody, that it insists on a kind of demotic, which limits it. There's not a lot of high-performance skill involved, except for Les's [Murray] work. Technically they're not as good as Americans or the best of the Europeans. I've never been a person who believed in this colonial and cultural cringe, but you've got to be careful about this, because I think it was Bob Hughes who pointed out the cultural cringe can all too readily become the Sydney strut [*laughs*]. There is a vulgar self-confidence in Australia today that strikes me as hardly an improvement on the old cringe.

How has the Australian landscape inspired your poetry?

A number of times I've written about the estuaries. Amongst the settled part of Australia, it's a coastline of shallow estuaries and sandbanks and small rivers and I find it very attractive. That would be my emblem of the Australian appearance, rather than out west. In Australia everything started from one city and went out. So I believe the nucleus of the city is the real hub and heart of Australia, rather than the bush.

What did you think of your portrait being taken?

Robert Burns said 'O wad some Pow'r the giftie gie us, To see oursels as others see us!'. Well you can't. You really feel like a poddy calf in a sale yard. All you know is that they are looking at you, you don't know what they see. Most representations in portraits are disappointing, but they are probably true. Auden thought that photography was an anti-human art because the camera catches a person in a split second. In movement we never settle to one image, so a photograph becomes a choice of image. An ordinary photograph is to a human action what a holy picture is to the story it represents. It represents only an image of the human life, not the life itself.

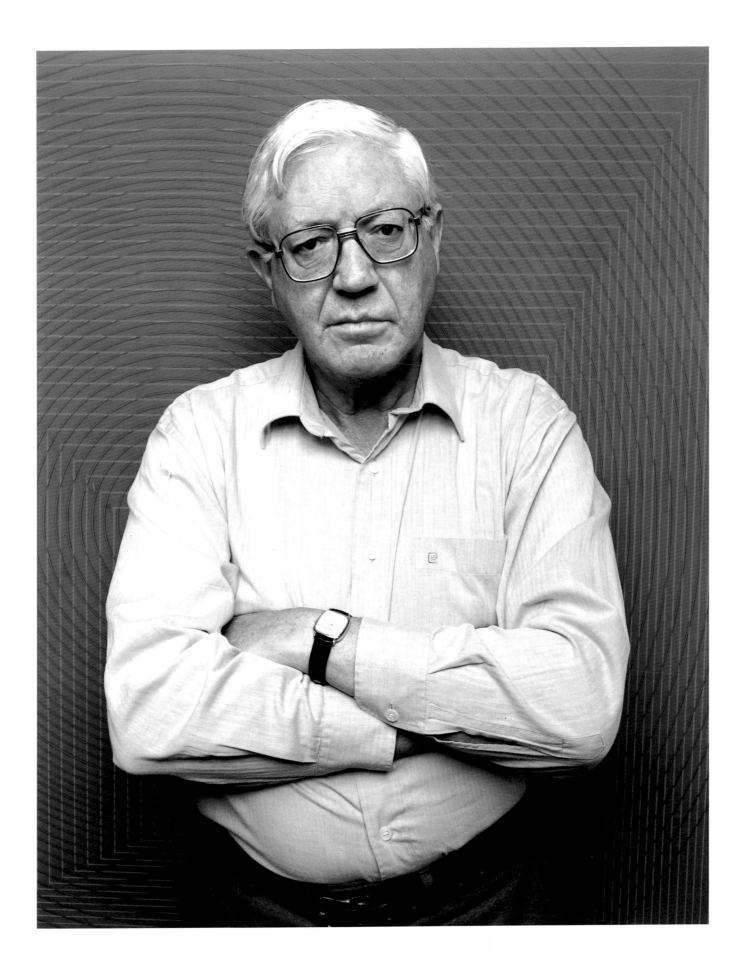

Sir Kit McMahon
Banker

Born in Melbourne, 1927. Sir Kit attended Melbourne Grammar School
and then the University of Melbourne from which he graduated with first
class honours in English and History in 1949. He worked as a university
tutor in English Literature for a year and then left for the UK in 1951
where he gained first class honours in PPE at Magdalen College,
Oxford in 1953. He joined the British Treasury as an Economic Adviser
(1953-60), was seconded to the Embassy in Washington from 1957 to
1960, and then served as Fellow and Tutor in Economics at Magdalen
College (1960-64). Sir Kit entered the Bank of England as Adviser in
1964, rising to Executive Director (1970-80) and Deputy Governor
(1980-85). He then moved to Midland Bank where he was Chief
Executive from 1986 to 1991 and Chairman from 1987 to 1991. Since
1991, as well as holding various business directorships, he has been on
the boards of the Royal Opera House and the Angela Flowers Art
Gallery. He received a Knighthood in 1986 and was made Chevalier,
Legion d'Honneur in 1990.

What did the UK offer that kept you here?

Since both my parents had died some years before I left Australia, I had no
close family ties to draw me back; and there turned out to be a succession of
stimulating and rewarding jobs to keep me in Britain. More fundamentally, I
found the sophistication, complexity and tolerance of the society here very
appealing. I was taken aback by the intensity and pervasiveness of the class
system and disliked many aspects of it. But I came to believe that, in a curi-
ous way, it was a factor in the tolerance – to me, perhaps the single most
attractive feature of England at that time – especially compared with Australia.
I felt I had escaped from a crude, instrusive populism, a tyranny of majority
opinion, and I liked the feeling.

Fifty years on, I see the relative situations as very different. Class-conscious-
ness here has greatly reduced, although as every Australian will testify,
nowhere near as much as the English believe. There has been an undeniable
growth in aggressive, populist banality (compare the Millennium Dome with
the Festival of Britain) and in the intolerance of special interest groups. At the
same time, it seems to me (this may be naïve – I have made only a handful of
short visits to Australia since I left it) that Australia has moved a long way in the
opposite direction. Certainly the chippiness has diminished as a genuine self-
assurance has replaced one that was proclaimed.

If I had my time over again, I would do just what I did before: come over here
and stay. But if I was starting again today, I am not so sure.

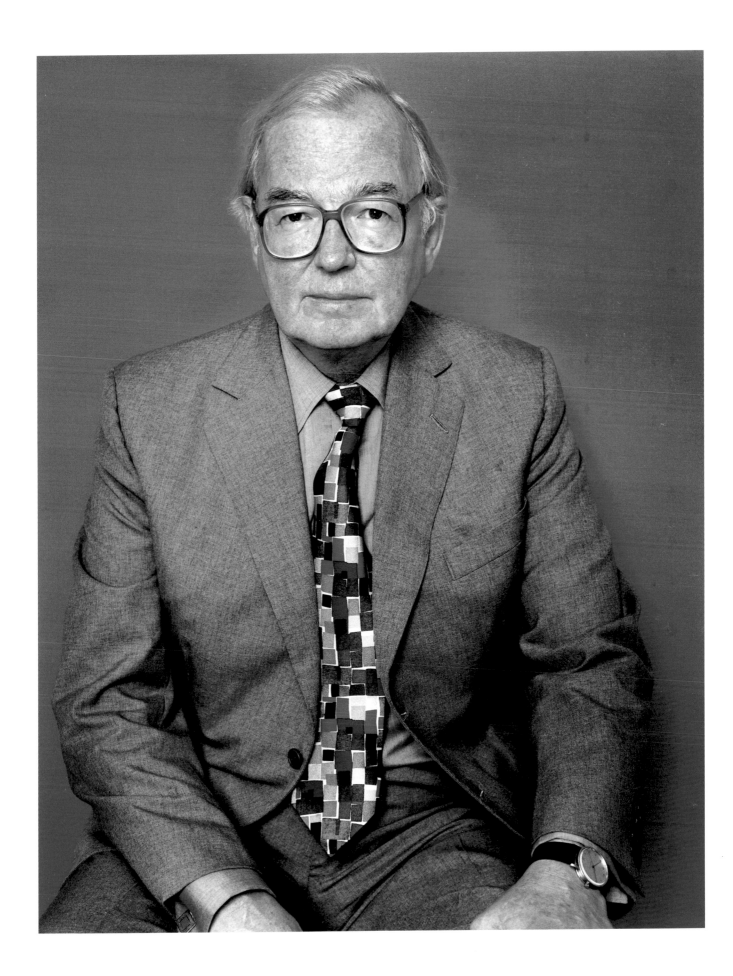

Peter Conrad
Author, Academic

Born in Hobart, Tasmania, 1948. After graduating from the University
of Tasmania in 1967, Peter Conrad took up a Rhodes Scholarship in
1968 at New College, Oxford. He graduated in 1970, winning a number
of prizes, including the Chancellor's English Essay Prize. Since 1973
Conrad has been Tutor in English at Christ Church, Oxford, but has
also taken up fellowships at Princeton (1975-6) and Williams College,
Massachusetts (1984). In 1993 he was awarded an Hon.D.Litt. by the
University of Tasmania. A regular lecturer in the US, Asia and Australia,
Conrad is the author of many books, a contributor to publications in
the UK and abroad, and a broadcaster on BBC radio and television.

Can you define what it means to you to be Australian?

Cheek, impudence. Cheekiness is a tremendous quality to have, particularly
in Oxford, because when you don't play by their rules, the English don't quite
know what to do with you. They can't kick you out of the club because they
perceive that you add a certain value to it. And I've probably learnt to exploit
that over the years. In the academic field, Australians display a slight reck-
lessness. Clive James said in his essay in The Fatal Shore that Australian
media magnates want to OWN the rest of the world, I think Australian intel-
lectuals want to KNOW the rest of the world. I think my Oxford contempo-
raries want to find their place in a whole structure that already exists, but I
don't want to occupy a niche in it, I want to re-conceive the structure.

On the Channel 4 television series, Queer as Folk, about these gay blokes
in Manchester, one of the characters, Cameron, an Australian, was very
sleek, and handsome and had his own house and was going to take this
pimply guy to Melbourne, of all places, for a holiday. This guy that lucked out
with Cameron couldn't believe it and went back to the bar the next day and
said to some of his equally nerdy British colleagues: 'I can't imagine what
Cameron sees in me. I can't be the best shag he's ever had – after all he IS
Australian'. That has to be the best compliment that Australia has ever been
paid, as a sign of envy of Australia the English now have, because they see
it as this very sleek, sexy, suntanned place, with very good food. Australians
have a sense of physicality; an impudent ease of their own bodies. I'm not
sure if I entirely possess it. But when I see my Oxford colleagues with their
necks throttled by ties every day, I realise I've hardly ever worn a tie in my life.
I remember that wonderful poem by Les Murray, The Dream of Wearing
Shorts Forever.

What is your image of Australia's development now?

When I left, it was at the bottom of the world and it was permanently anchored
there. And if you left, you left for a long time, because when I first came to
England by ship to take up my Rhodes Scholarship, it took about five weeks.
The journey by ship was an epic, it was like a great saga of migration. Now
anywhere can be the centre of the world. So there's no longer the sense of
geographical and cultural inferiority which used to exist. It's a country which in
the last twenty or so years has just re-invented itself, re-invented its own his-
tory, it is no longer just a facsimile of Britain.

I think of Australia now as being like the United States without all the crap.
It's a chance to do the United States all over again, but do it better [referring
to multiculturalism]. [But] this is foolish optimism, in a way, it's a product of
patriotism at a distance, because you realise there are still dreadful obstruc-
tive self-serving politicians who are standing in the way of the country's re-
invention of itself. But the result of the recent referendum on the republic
seems to me to reveal something that is tremendous about Australia, and that
is the democratic contempt of the people for politicians.

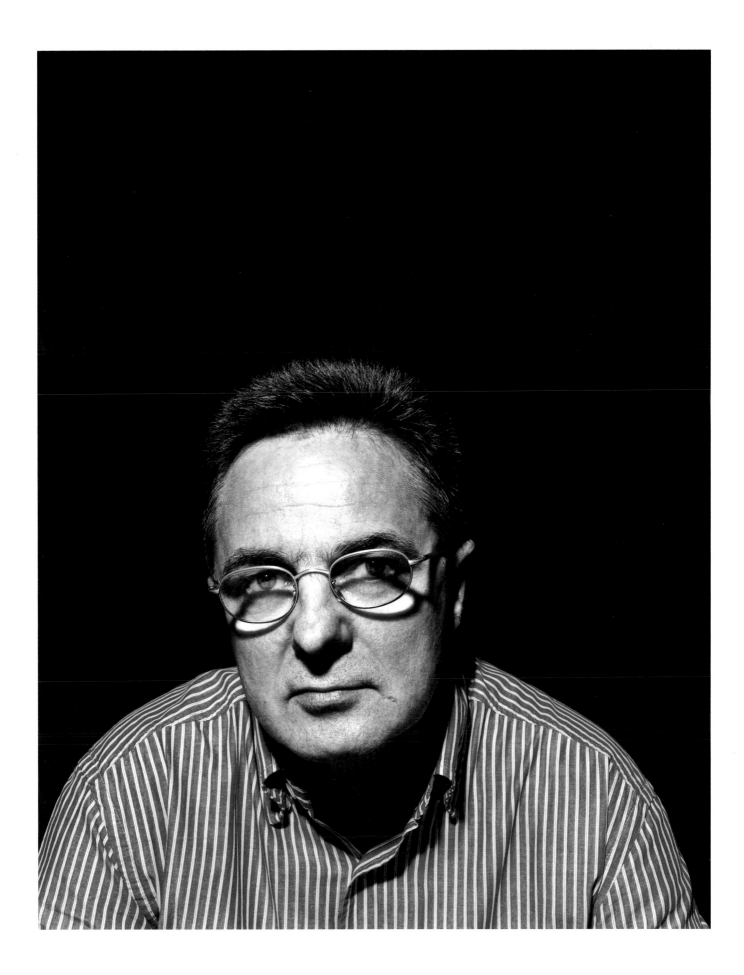

Alan 'Fluff' Freeman MBE
DJ, Pop Icon

Born in Melbourne, 1927. Alan 'Fluff' Freeman started his career
as an announcer on Melbourne's 3KZ. His stint as a summer relief
disc jockey with Radio Luxembourg in 1958 led to work with the
BBC on *Records Around Five* in 1961. Freeman went on to present
Pick of the Pops on Radio 1 until 1972 and then the BBC's
award-winning *Saturday Rock Show* which he presented until 1978.
Since then he has hosted a *Pick of the Pops* show on Capital Radio
and on BBC Radio 2. His catchphrases include 'Greetings Pop Pickers'
and 'Alright'. In 1987 the Radio Academy rewarded Freeman for
'An Outstanding Contribution to UK Music Radio' and in 1988 he was
honoured by Sony as 'Radio Personality of the Year'. He was awarded
an MBE in 1998 for services to music.

How were you received as an Australian when you started on radio here?
I had a great ambition to sing in opera as a baritone, and when I knew that
wasn't going to happen, I wanted to get somehow close to music. So I just got
lucky, thanks to Radio Luxembourg and the BBC. I really have been blessed,
I assure you. Everyone was lovely. The English just accepted me for what I am.
I arrived here when the scene was starting to happen. It was very exciting
being at the birth of real pop and rock music. When I left Australia in 1957, I
was doing classical shows, quiz shows, newsreading; rock 'n' roll hadn't quite
struck as yet. I knew that with the advent of rock and pop, I wanted as a pre-
senter not to override the music, but have the music speak. I still believe after
forty years that when people are listening to me, they're listening for the music.
I coined a phrase a long time ago: that the best disc jockey in the world runs
a very bad last to the worst record he ever played. And I still believe it, the
music is the thing that dominates.

Who were you inspired by?
There was one great broadcaster in Australia called Norman Banks. It was a
dream to hear him interview people. He was sensational and he had a terrific
voice. He inspired me because of his great knowledge. I did a whole show
with him here in the 1960s which was wonderful.

How do you see Australia now?
Australia without any doubt is the up-and-coming country. And I think they will
lead the way. I haven't lived there for forty years, when I go back now to
Sydney and Melbourne, they're very modern cities, with every facility. And dis-
tance has just disappeared.

How do you think Australia should change?
I've got no idea darling. Unless I lived there and saw how it was being run,

I'm not a politician, I'm a music man [*laughs heartily*].

How would you describe yourself now?
I guess by now I'm a Pommie Australian and just terribly happy that I'm still
accepted after all this time.

If this was your programme, how would you like to sign-off?
All right, stay bright. All right, kid? God bless you. Take care. Tarah.

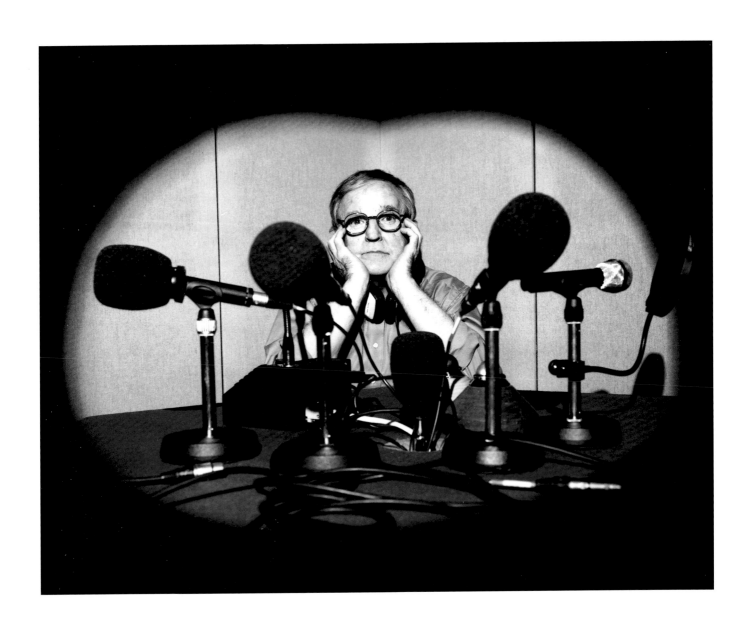

Rebecca Hossack
Gallery Owner

Born in Melbourne, 1955. Rebecca Hossack graduated with a law
degree from Melbourne University and an arts degree from the
Australian National University (1979). In 1980 she travelled to London
to study for the Bar at the Middle Temple. She transferred instead to
a Diploma in Art History at Christie's in London and in 1982 won a
scholarship to study at the Peggy Guggenheim Museum in Venice.
After gaining a Business Sponsorship of Art Award in London, she
opened the Rebecca Hossack Gallery in Fitzrovia in 1988, regularly
exhibiting Australian Aboriginal art. Hossack opened a second gallery
and sculpture garden in Piccadilly (1991-94). She was appointed
Cultural Attaché to the Australian High Commission (1994-97) to
promote cultural exchanges between Australia and Britain.

Polly came and took the photo in my flat in the bedroom. She worked fast
because she was heading off later that afternoon to Italy to photograph 'La
Cicciolina'. I felt rather staid in comparison. Within moments of meeting, we
discovered that we had Melbourne friends in common, that our sisters had
been to school together, that we knew each other's old boyfriends, that we
didn't support the same 'footie' team.

That's certainly one of the things I miss about Australia – its social smallness,
the other is its geographical vastness: the wide-screen landscapes and the
360° skies, and the smells and sounds of its abundant sunburnt nature. In
England, of course, the equation is the other way around – and that has its
excitements too.

Carmen Callil
Writer, Publisher

Carmen Callil was born in Melbourne in 1938 and has lived in London since 1960. She founded the Virago Press in 1972 and was its Managing Director until 1982 and its Chairman until 1995. From 1982 to 1993, Callil was Publisher of Chatto & Windus and The Hogarth Press, now part of Random House publishing companies, for which she was Editor-at-Large (1994-95). She served as Chairman of Judges for the Booker Prize for Fiction in 1996. She is now a critic and writer, collaborating with Colm Toibin on *The Modern Library: The Best 200 Novels in English since 1950* (Picador, 1999). Her current work, *Darquier's Nebula: A Family at War* is set in Vichy France.

What is your experience of being an Australian in the UK?

I was never one of those Australians who thought of England as home. Probably because I never had any English ancestors, they were mainly Irish and Lebanese. So I always felt very Australian. I always felt England was a place I had to look after, because of the war. I felt terribly sorry for them because they suffered so much. I've loved living here because the English are so strange to me. I find them utterly baffling. They are devious, unforthcoming and you never know what they're thinking. But wonderful to live amongst because they're tolerant and interesting. Non-judgemental. I like the fact that they're not fascistic, [*laughs*] I like their sense of humour. The Australian sense of humour is different, but part of it is English and I think that's one of the joys of living here: irony. Another reason I've had such pleasure living here, is that I was brought up on English literature, and that has been my world and my life.

What do you miss about Australia?

Weather, food, laughter, language and manners. Lack of. I prefer the way Australians treat people to the way British people do. They're much more open. I think the English are far too concerned with face, in a Chinese sense, and with manners. Those are both things of no interest to me. And their obedience is still something that baffles me completely. I think Australians are much more bloody-minded and they put up with much less.

But you survive?

I survive but not without effort [*laughs boldly*].

Are there down-sides to being an Australian here?

I think the most tedious thing in my life was the general sense of English astonishment that I was well-educated and had a brain. That gave me the pip

[*pointedly*]. So I suppose one has to admit, that as much as one loves them, they are a patronising bunch. You need to have the hide of a rhinoceros.

Why did you leave Australia?

It was post-war, very Catholic and it was hell.

What will the new millennium offer Australia?

Five more conservative governments, six royal visits and a partridge in a pear tree – or a wombat in a gum tree.

Is that what Australians deserve?

No punishment is too great for their vote not to become a republic.

Did the Wallabies Rugby win compensate for the loss of the republic vote?

No way, José. Although the cricket win did a bit.

Can you compare the literary cultures in the UK and Australia?

There is a broader canvas here and the tradition is stronger here. They're not better readers though – our education is certainly better in Australia. The big change in my lifetime is the interest in Australian writers. In my day you read English writers, but I think it's still an uphill struggle for Australian writers because of the distance. I think the British control over the Australian market should go, absolutely. Australians should be able to buy books from wherever they like, not just from Britain which controls the Australian market.

What did you think of the shoot?

I thought Polly was a genius. You can always tell. I've got this funny library and she took all the lights and moved them up so that they looked like a halo and I've kept them like that. I've lived with them all my life and she moved them around and now they look fabulous. And also I loved her accent. Which is pure, pure Melbourne. That gave me enormous pleasure. I could have listened to it for quite some time [*savouring the memory*].

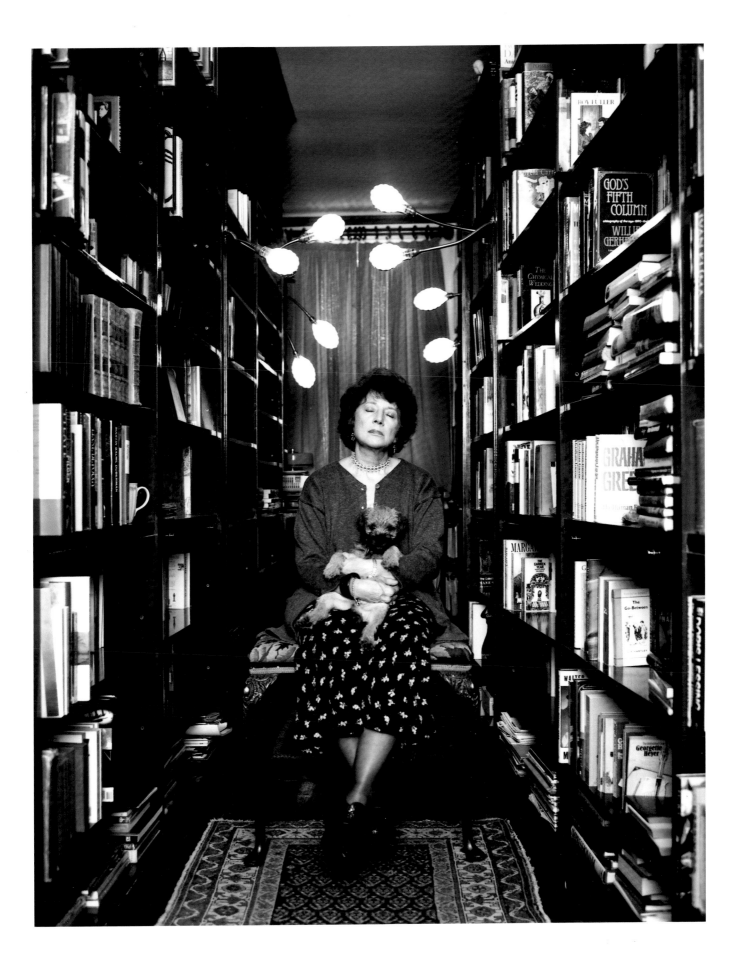

Roger Cook
Investigative Broadcaster

Roger Cook was brought up in Australia where he began his broadcasting career with the ABC. He moved to the UK and worked as a reporter with BBC Radio in 1968 on *The World At One,* which he later presented. Cook created *Checkpoint* in 1973 and he also worked as an investigative reporter on BBC's *Nationwide* and *Newsnight.* In 1985 he joined Central Television and *The Cook Report* was born. The programme has exposed child pornography, protection rackets, baby trading and war criminals, leading to the successful prosecution of villains or major changes in the law. Cook has been honoured with many awards including the 'ITV Programme of the Year' (1993) and the Special Award from BAFTA (1998) for twenty-five years of outstanding investigative reporting. His publications include *What's Wrong With Your Rights?* (1988) and his autobiography *Dangerous Ground* was published recently.

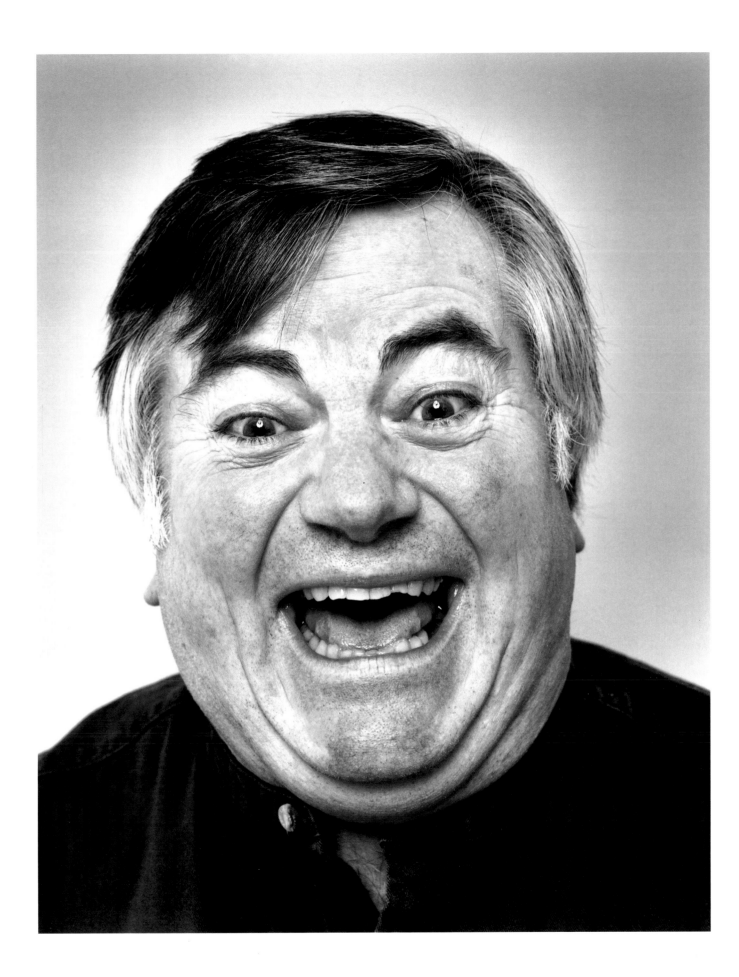

Leon Davis
Chief Executive, Rio Tinto

Born in Port Pirie, South Australia, 1939. Leon Davis joined the CRA
Group in Port Pirie in 1956 as a metallurgical cadet. He was appointed
Managing Director of Pacific Coal in 1984 and held positions with
Bougainville Copper in Papua New Guinea and with Conzinc Asia
in Singapore. In 1989 he became Group Executive of CRA Limited,
and Mining Director of RTZ in 1991. He was appointed Chief Executive
of CRA in 1994 and after the dual listed merger of CRA and RTZ,
was appointed Deputy Chief Executive and Chief Operating Officer
of Rio Tinto in London in March 1996. He has been Chief Executive of
Rio Tinto since 1997.

Are you in the UK for a certain period?
Until I retire – when I will return to Australia.
What are the advantages of the UK?
It is close to other countries and cultures; being on the doorstep of Europe
and with long-standing links and proximity to North America is a rewarding
experience. Having access to a diversity of views and opinions is something
that's pretty unique.
What is your perspective on Australia now?
We need to understand that change is continuous. We need to think seriously
what kind of nation we wish to be and how we wish to structure our leadership
for the long term. We need to look at our institutions. For example, a lot of peo-
ple think we have a Westminster system of Government but we don't. It is a
hybrid between the Westminster system and that of the USA. We need to
examine these institutions to see if they are still functioning as well today as
the designers of our constitution envisaged them a hundred years ago. I
would like us to be at the forefront of social and political thinking. We once
were: Australia was, for instance, one of the first democracies to give women
the vote. We need to regain that position and we need to do it through con-
structive debate.
Do you think Australians have become complacent?
No, not complacent, a bit worried about the price of change perhaps. The
whole debate on native title and the rights of our indigenous people is still
something that is only inching forwards. I think that we're taking too legalistic
a view of the whole thing. As somebody once said, it is easy to do justice but
very hard to do right. We should try and overcome the legal obstacles and
focus on the right thing to do and how best to do it.

What is Rio Tinto's view?
Back in 1994, we were the first mining company in Australia to implement the
recognition of the tenets of native title, and tried very hard not to get tied down
with the minutiae of the legal argument. We set about training our people to
understand the rights of indigenous people, started discussions with indige-
nous people where we operate and tried to include them in the whole decision-
making process. It [Rio Tinto's attitude] is fairly well known in Australia.
What should Australia be producing as its manufacturing base is weak?
I don't think Australian manufacturing is weak. That's an old myth. Australia's
manufacturing has grown quite remarkably in the last ten years and it could
be the powerhouse for Asia. Where manufacturing hasn't been competitive,
the tertiary sector has taken up the slack. Australia can supply the drive, the
capital, the intellectual horsepower, it can be the bridgehead of Europe into
Asia because Australia is an Asian country with a predominantly European cul-
ture and institutions.
What do you miss about Australia?
The weather and the other half of our family.

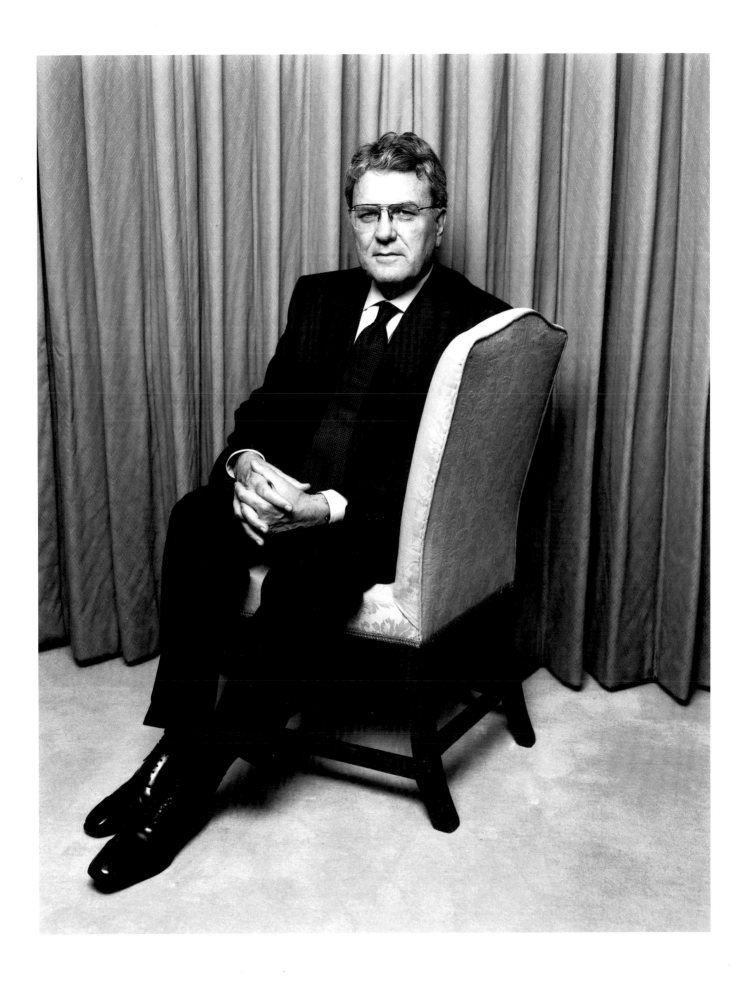

Janet Holmes à Court AO
Businesswoman

Born in Perth, 1943. A graduate in science from the University of Western Australia, Janet Holmes à Court is Executive Chairman of the Heytesbury Group of family companies, whose interests included Stoll Moss Theatres, London's largest group of theatres. Currently Chairman of the Australian Children's Television Foundation, Holmes à Court was appointed Officer in the Order of Australia in 1995 for services to business, the arts and the community. In 1996 she became the Veuve Cliquot Business Woman of the Year (UK). In 1998 she represented the Australian Republican Movement at the Constitutional Convention in Canberra, and was awarded the International Business Council of Western Australia Award.

What does being Australian mean to you?

What I hope it means is having a sense of fair play. And for me it's very much being part of, what one always hopes is, a less hierarchical society than I find in the UK. When I first went into Stoll Moss, there was a much more hierarchical management structure in place. People are probably pigeon-holed much more in technical, or what are seen as lower level, jobs in the UK and there's possibly not as much mixing across different levels of structures within companies. Occasionally I would ask someone at Stoll Moss what they did and they would reply 'I'm only an electrician' or 'I'm just an usher'. And I just won't have the word 'just'. We can't operate without electricians and ushers, they're all very important. I think the people have welcomed [this approach]. Maybe some of the very senior people thought it was a bit... peculiar. Nobody has said it's an odd way to behave, but it's not the traditional way in which companies in England have been run.

What qualities do Australians and the English share?

I think the Australian and English sense of humour are very compatible. I've been in situations where I've watched Australian movies with Americans and laughed uproariously and not had a flicker of a smile from the Americans, but English people get it.

What is your view of Australia now at the turn of the millennium?

It's no secret that I was a great supporter of the move for Australia to have its own head of state who was Australian. My republicanism is nothing to do with being anti-British or anti-Queen, it's about being pro-Australian and having an Australian head of state who represents who we are and what we are now. And right now we have representatives of 184 different nations with dozens of different religions living in Australia, and for us to have a head of state who is a monarch of another country 12,000 miles away, and who has to be an Anglican and has to be English is not in sync with what Australia is at the moment. I'm a bit disappointed that Australians don't feel that there is anyone in their country capable of being the head of state.

I think many Australians feel alienated and forgotten by politicians. There is a lot of disillusionment, a lot of people feel disenfranchised. There are enormous divisions opening up in our society. In the state of Victoria recently a seemingly popular government was completely thrashed at the polls, and that was the people saying: 'Come on, listen to us'. That has sent a very loud message to politicians in all the other states in Australia, and I think we will see politicians sitting up and taking more notice of their electorate, not just rolling ahead and doing exactly what they feel they want to do. We need politicians who will govern for the people, not simply run the economy.

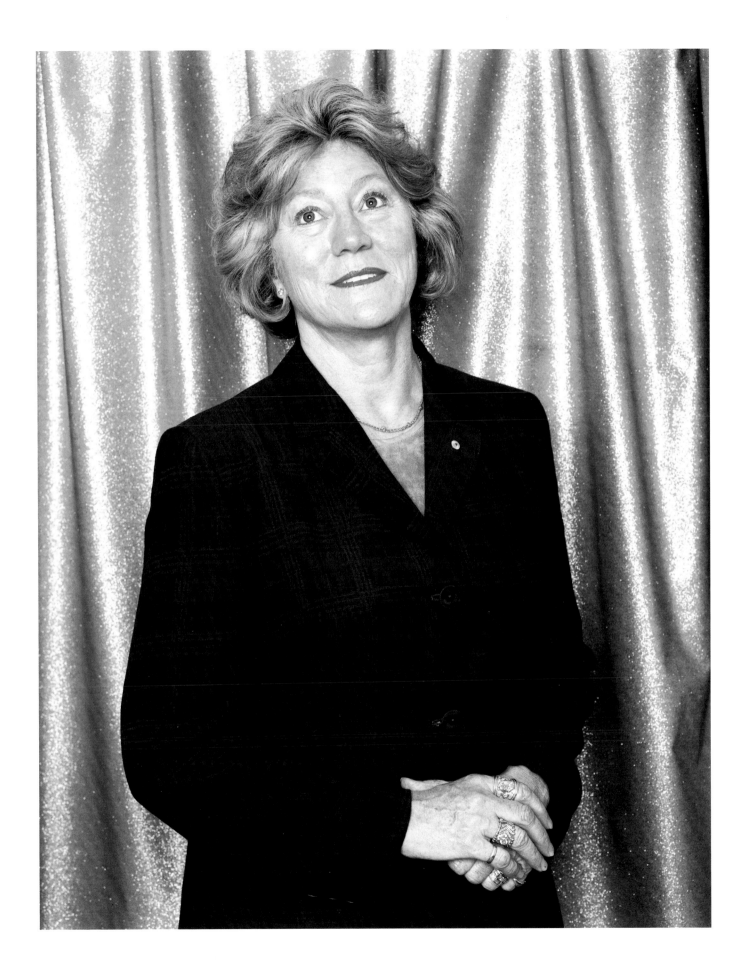

John Pilger
Journalist, Author, Film-maker

Born in Sydney, 1950. John Pilger began his career in journalism on Sydney's *Daily Telegraph*. He left Australia in 1962 for Italy, where he was a freelance correspondent before joining Reuters in London. From 1963 to 1986, he was a reporter, feature writer and, later, Special Correspondent on the *Daily Mirror*. In 1970, he began a parallel career in television and has since made fifty-two documentaries for Independent Television (ITV). Many of his films have had extraordinary influence, notably *Cambodia Year Zero* (1979), which alerted much of the world to the horrors of the Pol Pot genocide, and *Death of a Nation,* highlighting East Timor's long struggle for independence. His publications include *Heroes* and *A Secret Country*, about Australia. Awarded honorary doctorates in literature, philosophy, the arts and law, he twice won the Journalist of the Year award. He has been International Reporter of the Year, and holds the United Nations Media Prize Gold Medal (Australia) and Academy Awards in the United States and Britain.

What defines you as an Australian?

I was born and brought up in Bondi, Sydney, and my love of sun and surf and the exquisite idleness found on a beach is unchanged. Like a Hindu drawn to the Ganges, I return to Bondi or any fine Australian beach at every opportunity. I also like to think that a sardonic sense of humour defines me as an Australian. It comes from our convict heritage; unlike the American settlers, who were on a mission from God, the first white Australians were mostly Godforsaken. And there is the 'fair go' myth. It's a myth of course, but I like the *idea*.

What has changed about Australia?

When I was growing up, Australia was a second-hand Anglo-Irish society living in fear that Asians might fall down on us as if by the force of gravity. Since then Australia has become the second-most culturally diverse nation on earth, and it has been done with the sweat and tears and hopes of ordinary people, if largely by default, and without blood on the streets. It is a great achievement, and it would be wonderful if it included the Aboriginal people, whose ill-treatment and political betrayal are our continuing shame. Unfortunately for us whites, until we give back Aboriginal nationhood, we can never claim our own.

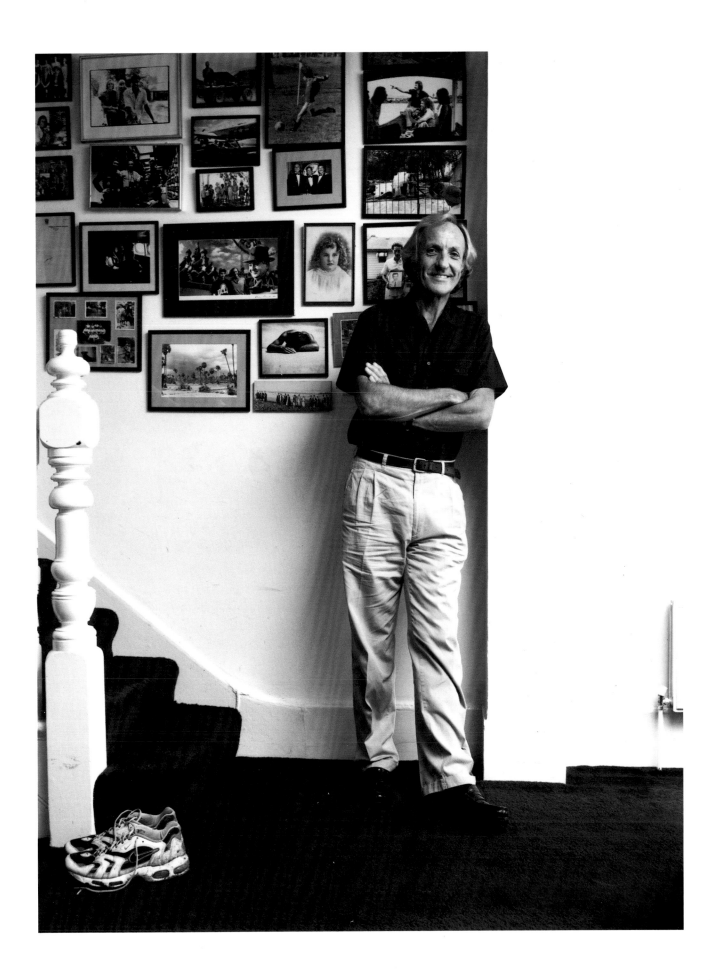

Tony Clark
Artist

Born in Canberra, 1954. Tony Clark moved to London with his family
in 1960. After graduating from Reading University, he returned to
Australia to live, but is now based in London. Clark was Artist-in-
Residence both at Ormond College, Melbourne University from 1987
to 1988 and at Delfina Studios, London in 1999. His recent individual
exhibitions include *Meltdown* at the South Bank, London (1999) and a
show at the Roslyn Oxley 9 Gallery, Sydney (2000). Group exhibitions
include *Looking at Decoration*, the Museum of Contemporary Art,
Sydney (1998) and *Documenta IX* (1992). He was awarded the John
McCaughey Memorial Art Prize, Melbourne, 1994. His works are
held in the public collections of the Art Gallery of New South Wales,
Sydney; the Museum of Contemporary Art, Sydney and the National
Gallery of Victoria, Melbourne.

How did the shoot go with Polly?

I was wearing a combination of Arab clothing that I'd picked up in the
Palestinian part of Jerusalem. In the picture, I'm gazing at myself in the mirror,
so there's a profile shot, you don't get the full face looking back at you. It's like
a double image of profile and a concealed frontal image.

Was this artistic symbolism?

No [*aghast*], not in this slightest. We just tried as many things as you can try
in a lounge-room setting. She shoots a hell of a lot of pictures, and this was
no exception.

Are there characteristics or instincts that apply to your work which you would
identify as Australian?

Absolutely. I think I would have found it very difficult to get started as an artist
in England. It was fantastic for me to have had the uninhibiting factor of being
in Australia to get started. I studied History of Art in England which was rather
inhibiting. A lot of creative people in Australia have a healthy do-it-yourself atti-
tude. That's something that really can be turned to one's advantage. My work
as a painter is primarily about doing do-it-yourself versions of complex refined
prototypes. Something I enjoy about Australia is that it encourages you to
have a go. Whereas I've found that in Europe generally, the attitude is not
'Have a go', but 'Back off' [*laughs*]. On the plus side, my life's blood as an
artist are the British Museum and the Victoria and Albert Museum. I'm addict-
ed totally to them and I can't imagine life without them. So it's essential I spend
time in those places. There just isn't a highly developed centuries-old culture
of collecting in Australia.

What's your take on Australia now?

It took the experience of being away from Australia for me to understand the
moral obligation that Australians have to take a concerned interest in
Aboriginal culture. While I remained indifferent to all that while I was living in
Australia, it's become much more important to me since I left. So when I do
visit, I make a bee-line for the Aboriginal galleries in Australia. It's not so much
[that they provide] inspiration, but one has a sense of obligation to take note,
as a citizen really, rather than as an artist.

How are attitudes to art changing in Australia?

Young people's art is pretty global these days and there are good and bad
things about that. The specifics of Australian art are getting ironed out of the
picture, which is the downside. The upside is that young Australian artists feel
a greater sense of possibility and participation in the global scene than my
peers had ever felt.

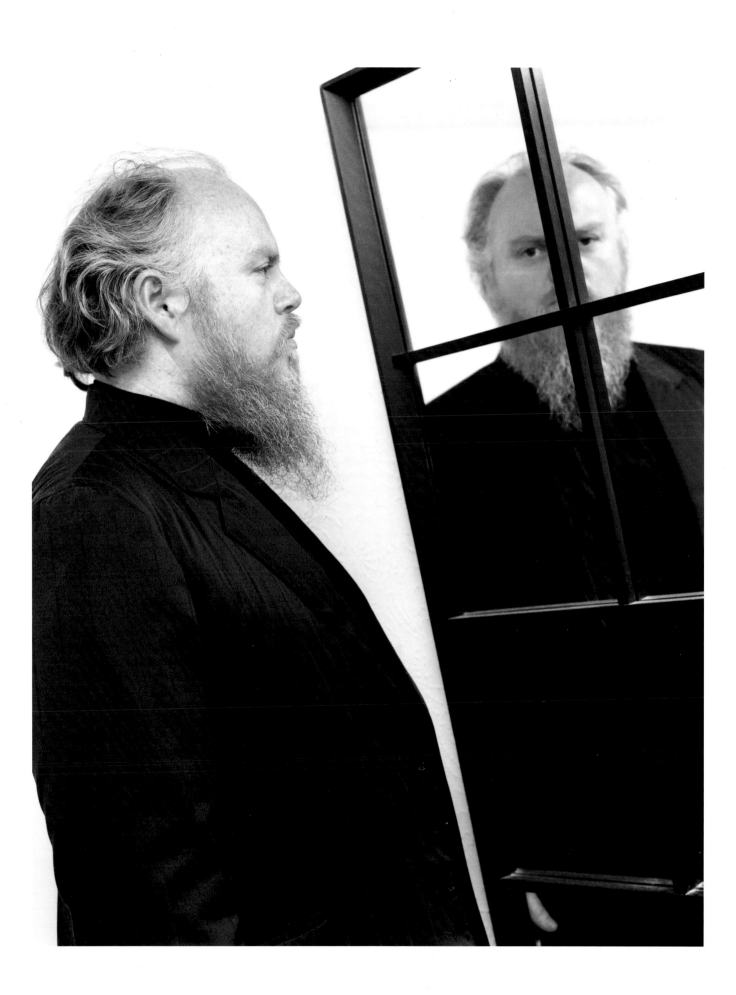

Pat Cash
Tennis Player

Born in Melbourne, 1965. Having turned professional in 1982, Cash
reached the quarter-finals of the Australian Open the same year, and
again in 1984. In 1983 Cash reached the semi-finals of the US Open
and Wimbledon Championships, and won Australia's Davis Cup. He
moved to the UK in 1985 and reached the quarter-finals at Wimbledon
in 1986 and the finals of the Australian Open in 1987. In 1987 Cash
won the Wimbledon Championships Final, famously climbing through
the audience to embrace his family. After winning the Hong Kong
Tournament in 1990, he suffered repeated injuries, but qualified again
for Wimbledon in 1997. Cash announced his retirement from the circuit
in 1999 to pursue his business and media interests.

Sent via e-mail from the Australian Open

I decided to move to the UK for practical reasons because I travel and play
in Europe a lot. [Also] my friends are here, all my favourite bands are
English, so I can see them in concerts. And London is the friendliest big city
in the world. I don't care what anybody says. I've been to them all. I get into
a cab in New York or Sydney, they won't know where the hell they're going.
I don't know how many times I've got into cab [in London] and the driver
says 'You want to go home, Pat, no problem, I know where you are'.

I would like to move back but I'll always be around England. I'm starting the
Cash Hopper tennis academy on the Gold Coast in Australia. Australia is a
successful sporting country and our standard is higher than many other
parts of the world. We just love our sport. It's the bottom line. We want to do
well. Australia will become one of the leading countries in the world. We're
technically, medically, scientifically, very advanced. The US will have to take
a back seat to us in the near future. The world is being shaken up environ-
mentally, we're seeing more and more disasters. I don't want to be a dooms-
day person, but there are obvious signs that there is serious trouble in the
world in the environment. I'm heavily involved in the environment in Australia,
I started Planet Ark, an environmental group in Australia. And Australia is the
true safe haven for the world.

[Wimbledon Finals, 1987, Pat Cash vs Ivan Lendl]
When I won the final, I was sitting in my chair looking up to my family and coach
who were waving and smiling. The win was very much a team effort: my dad,
sister, girlfriend (my son was in the crèche), my uncle, my coach, a good

English friend, my fitness trainer and my psychologist were all up in the box and
it just didn't seem right for me to be separated from them. I ran off to try and
get to see them in the players' box area, but I didn't know the way and I would
have got lost, so I headed straight up the stand. As I got half-way I realised
there was a big gap where the standing public were (that area has gone now;
people used to wait all night and when the gates opened in the morning, they
would run flat-out to the front of that pit). I couldn't jump twenty feet, but I could
not give up, so I had to climb over the commentary booths to get to them.

It was a special moment that everyone enjoyed. There was an attempt by the
press to get a negative response from the All England Club because I did
leave the Royal Family waiting. (Although I know Princess Diana enjoyed it,
when we talked about it at a later date.) But the officials were supportive –
mind you, they did ask me not to do it again if I won. Other players have done
it since; unfortunately, I never had the chance again. I'm not sure if it was an
Australian reaction or not. I have a lot of respect for the Wimbledon title and
the joy of winning it was evident. I had some great moments and emotions
with the Davis Cup team in 1983 and 1986, but this was my moment. I just had
to share my happiness with the people who were important to me.

I have never heard a negative response to what I did. Many people came up
and told me how emotional they felt when they watched me. The special ones
were the men who were dealing with the relationship with their fathers. I think
the sales of Kleenex tissues went up that week.

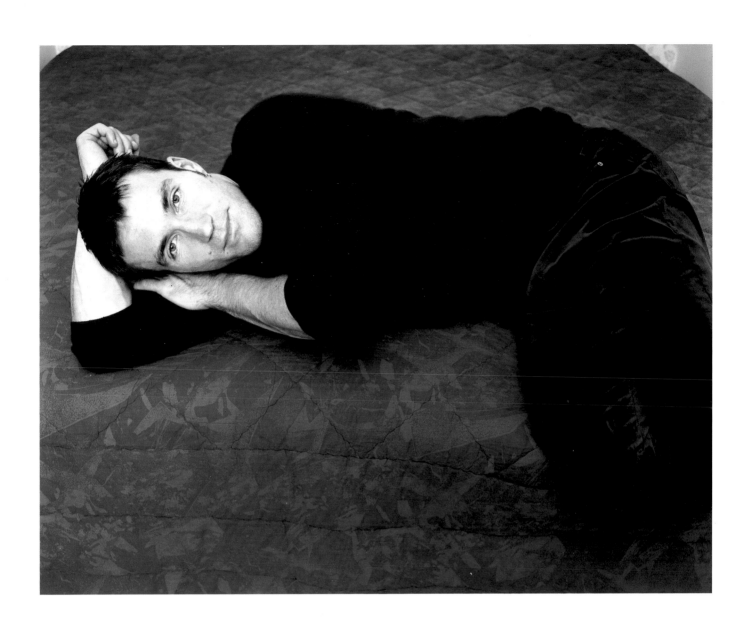

Kylie Minogue
Singer, Actress

Born in Melbourne, 1968. Kylie Minogue's television debut was in
Skyways at the age of eleven. In 1986 she joined *Neighbours* to play
the popular character Charlene, winning five Logies (the Australian
equivalent of an Emmy), including the Silver Logie for Most Popular
Actress, and in 1988 the Gold Logie for Most Popular Personality
on Australian Television. Minogue had her first record success with
Locomotion in 1987 and since then she has had twenty-nine worldwide
hits, released six studio albums, several videos and a Greatest Hits
album and a live album. Minogue's film credits include *The Delinquents*
(1989), *Streetfighter* (1994), *Hayride to Hell* (1995), *Bio-Dome* (1996),
Sample People (2000) and *Cut* to be released in 2000. In 1999
Minogue released a book entitled *Kylie*, a vivid self-portrait of her many
different personas, public and private, both reflected in the eyes of
others and as seen by herself.

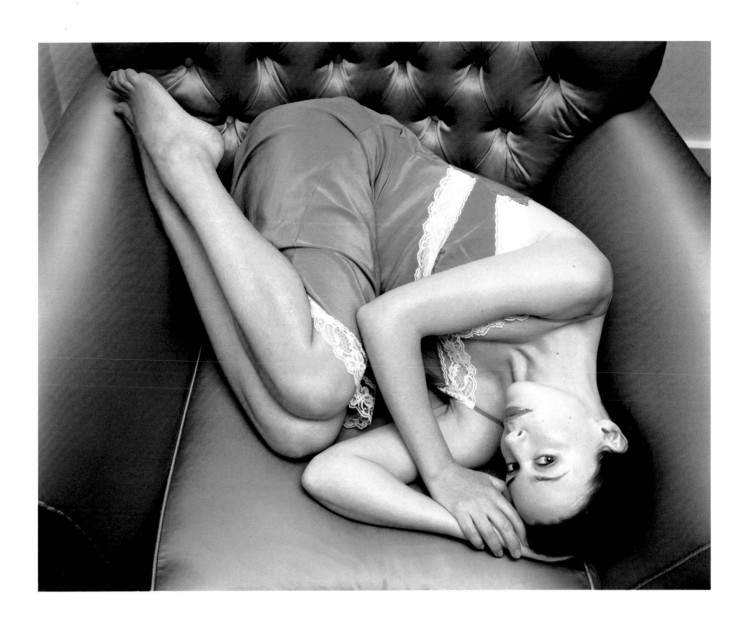

John Hillcoat
Film Director

Born in Brisbane, 1960. John Hillcoat grew up in America, Canada and
Europe and returned to Australia in 1978. He enrolled at Melbourne's
Swinburne Film School, where he produced two short dramas,
The Blonde's Date with Death and *Frankie and Johnny*. Hillcoat then
went on to direct award-winning music videos for artists such as
Nick Cave, Crowded House, Placebo and Suede. In 1988 he co-wrote
and directed his first feature film, *Ghosts of the Civil Dead*, nominated
for nine Australian Film Institute awards. His second film *To Have and
To Hold* was released internationally in 1998. Hillcoat continues to
create music videos in London and has several feature film projects
in development with producers and writers in the UK and the USA.

What has living in the UK allowed you to do?

The music video industry here is much stronger than it is in Australia, the
budgets are much bigger. But most importantly, you have much greater
choice of bands and musicians. In terms of feature films, my last film was
based in Australia and Papua New Guinea, which has a completely different
culture to Australia. Being in the UK has drawn me more towards international
cinema as opposed to a specifically nationalistic thing. The kinds of films I'm
interested in are difficult films. They're not mainstream blockbusters and
they're not Hollywood. Sadly, the number of independent Australian films has
radically reduced; the American film studios have moved in and it's become
Hollywood South. When I was last there, we inquired about using Warner Bros
studios, and Australians could not afford them, so they're really just for the
Americans who use the first-rate Australian crews and pay them so much
more than they would get on a small independent film. This has the result of
gradually eroding the strength of the uniquely Australian film industry.
Everything has gone global now and if you don't capitalise on that, especially
if you want to make films that aren't mainstream Hollywood, you can't do it in
Australia. Even a small independent film needs overseas distribution other-
wise you're not going to raise your money.

How do you view Australia now?

It's a sad, sad affair. We came over here during the Thatcher years and England
was very grim. Now when you look at the right-wing Liberal party in Australia,
it's like they're going through their dark Thatcher years, the main issue being
that of the Aborigines. It's become a kind of apartheid set-up almost, but South
Africa has progressed, whereas Australia has regressed. It's crazy in these
days of multiculturalism.

What about the shoot?

Polly: We had a video camera pointed at him and then we had the television
screen on and he was on the television screen via the video camera. We were
fighting madly because I was exhausted and we literally did it in ten minutes
and it's one of the best pictures actually. Although my printer said 'How could
you do that to your husband, it looks like a police mug shot, you've made him
look like a criminal'. But I love it, it's great.

John: I basically did what she wanted, up to a point [*smiles*]. She's very manic,
focused, almost possessed. She encourages the sitter a lot, gets them to relax
and then does what she wants. Without being biased, she is the best.

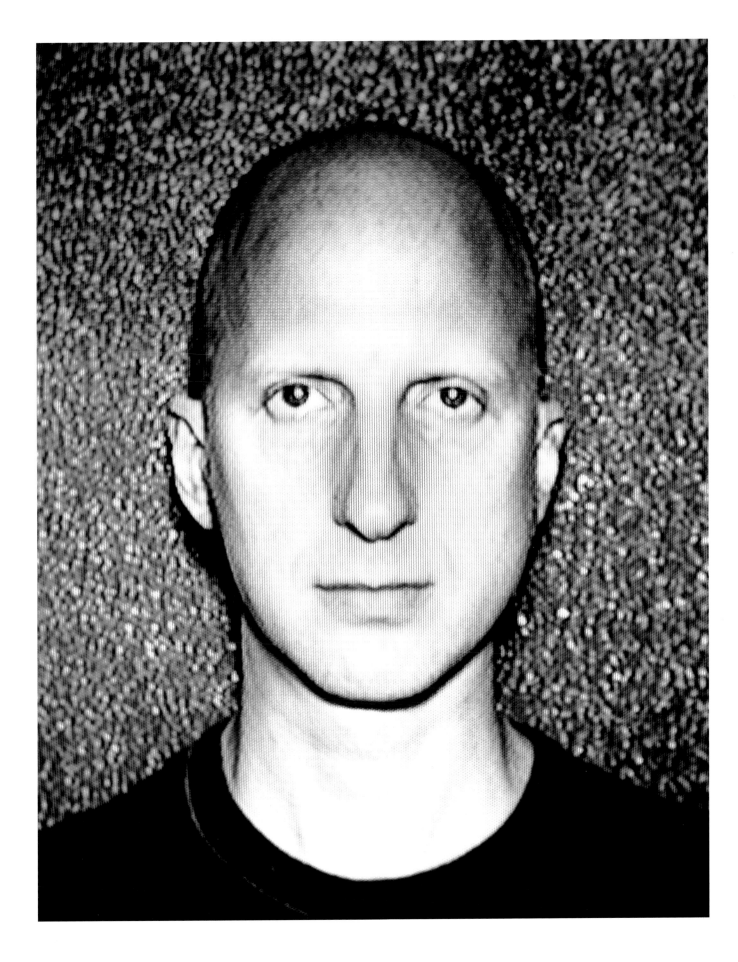

Elle Macpherson
Model, Actress

Born in Sydney, 1964. Confirming her as one of the most recognisable
supermodels in the world, *Time* magazine ran a cover story on her
entitled 'The Big Elle'. Highlights of her modelling career include covers
of the *Sports Illustrated Annual Edition* and her world wide sell-out
calendars (1992-94) which became the fashionable wallpaper of youth
around the world. In 1990 Macpherson piloted a lingerie collection,
Elle Macpherson Intimates and a men's collection was introduced
in 1998. In 1995 her fitness video *Your Personal Best Workout...The
Body* was voted the number one 'Special Interest Video' of the year by
Billboard magazine. *Sirens* (1993) marked her debut in feature films and
gained her a two-year multi-media deal with Miramax films. Her other
film credits include *If Lucy Fell* (1995), *The Mirror Has Two Faces* (1996)
and *Batman and Robin* (both 1997). Macpherson is currently guest star-
ring in the American sitcom *Friends*.

I have never really left Australia – I will always be Australian in my heart. I attrib-
ute my success to my family, my Australian education and my biggest gift of
all was to have been born Australian.

My view of Australia now is that it is the country of the future.

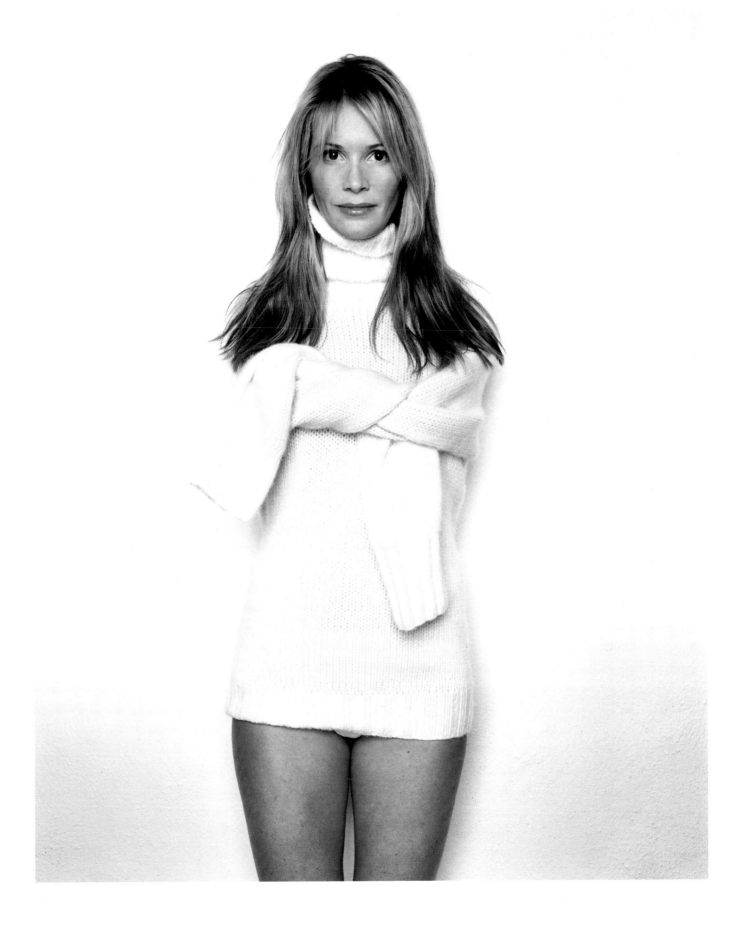

Leo McKern AO
Actor

Born in Sydney in 1920, Leo McKern came to England in 1946 and toured and performed for the Old Vic and other companies. Stage highlights include *Cat on a Hot Tin Roof* at the Aldwych (1958), and *Hobson's Choice* at Chichester and The Lyric (1995). Film credits include *The French Lieutenant's Woman* (1983) and *Travelling North* (1986). McKern stars as Rumpole in television's *Rumpole of the Bailey* series (1977). Other television credits include *Reilly – Ace of Spies*, (1983) and *A Foreign Field* (1993). His biographical memoir, *Just Resting*, was published in 1983 and he was appointed to the Order of Australia in the same year.

What brought you to the UK and what keeps you here?

I came originally to look for work in the theatre. Because London is the centre of the theatre world. I have always had an affection for England and particularly for Scotland, where I originally came from. My roots are half here and half there; it's a great problem. We have tried to return to Australia, twice, actually. Once in 1970, when I went back with a brand new Volkswagen Dormobile conversion, we went round Route 1 in over nine weeks and that was a great experience. We tried it again in the 1980s and it was very pleasant but it didn't work somehow [*reflectively*]. It was mainly [due to] work. My work more or less keeps me here. Although there's a great deal more work in Australia than there used to be. The country [keeps me here], and one feels much more part of history here. I think people are very much the same everywhere. I don't like what's happened in Australia, particularly since I've been away. I don't think multiculturalism works really. And I deplore what they're trying to do here in that respect. I think it works for some people, in some countries. I don't think it works here and I don't think it works in Australia. It's a different place now to what it was when we left in 1946 – for example, there wouldn't have been even the remotest thought of having a referendum about a republic.

Your reaction to the recent outcome?

The fact that it was to have a president elected by politicians – politicians stink as far as I'm concerned. I think they are a lot of hypocritical liars, who are out for personal power. I think Australians have had a contempt for politicians for as long as I can remember. I think they've been very unfortunate in their politicians. But I think Britain has too. But there are a lot more people watching here, and they can get away with more in Australia. But I love the country of Australia, not necessarily the people.

Do you miss the bush?

I do indeed. I miss the emptiness and the lack of people. There are too many people in this country. And too many of the wrong sort of people in Australia.

Are you referring to the impact of multiculturalism?

Yes, that's right.

Are you treated differently as an Australian in the UK?

Oh Lord, yes. The attitude now is very different. There is still unfortunately an attitude of treating Australians like colonials. But I think among the general public, it's changed enormously. When I first came over, people wondered why you weren't black, with a flat nose... one had all sorts of prejudice to fight against when one first came, especially when I talked like that [*broadening vowels*]. One had to get rid of that of course, quick and lively. To get work – at all. It wasn't until the *Summer of the Seventeenth Doll* [1955] came to England that there was such as thing as Australian theatre, and such a thing as Australians in Australian plays.

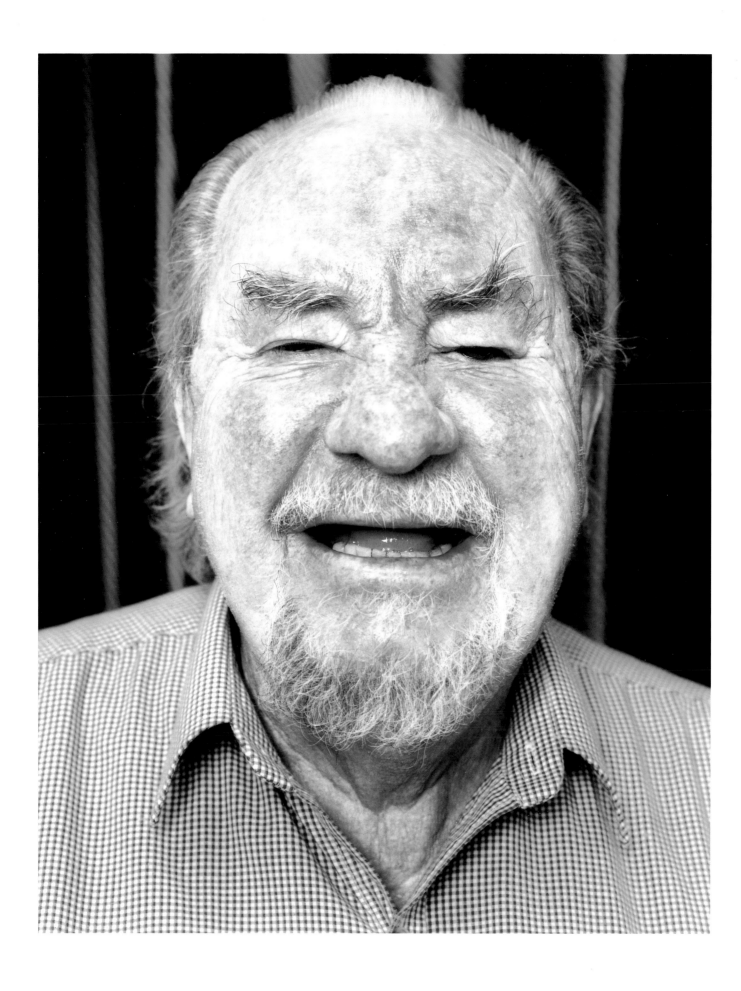

Lloyd Newson
Dancer, Choreographer

Born in Albury, New South Wales, 1957. Having studied psychology
and trained in dance with Margaret Lasica (Melbourne), Newson joined
Impulse Dance Theatre in New Zealand in 1979. He toured with One
Extra Dance Company to London where he took up a scholarship
with the London School of Contemporary Dance (1980-81). Newson
joined the Extemporary Dance Theatre and then co-founded DV8
Physical Theatre in 1985. The company has been honoured with many
international awards for its performance and for its films, of which
Enter Achilles and *Strange Fish* won two Prix-Italia awards and one
International Emmy. DV8 has been commissioned by the Sydney 2000
Olympic Arts Festival to make a new work, *Funnyland*, at Luna Park
in Sydney. The show will return to London to be performed with a
new title, *Wasted*.

What defines you as an Australian?
Sun-damaged skin, circumcision and a directness of speech.
What is your experience of being an Australian in the UK?
I keep realising, even after many years of knowing British people, that despite
having the same mother tongue, I am as fundamentally different to them as
any other race. As my passport states, I am an 'alien visitor', and I would add,
'programmed in the sun'. If you can weather the weather in Britain and accept
the nation's gloominess, it's the beginning of integration. At the joy of gener-
alising, I have a love/hate relationship with the English (as opposed to the
British), for in their reserve, manners and indirectness lie the most fantastic
complexities, contradictions and class divisions – all wonderful material when
making sociological and psychological dance theatre. I think I am a burr in the
side of the English dance-scape and in general they have the manners to tol-
erate me.
What is your view of Australia now, particularly in the context of the new millennium?
The geographical proximity, diversity of taste and access to arts funding in
Europe cannot be compared to Australia's isolation and limited arts provision.
The British were generous in offering me a full scholarship to study dance
when no such offer was available in Australia. It was only on the eve of the mil-
lennium that Australia found funds to commission a work from DV8. I am
grateful for that, but after the celebrations, I ask myself: Will anything have
changed in the way Australia funds the arts, and dance in particular?
In the shoot with Polly, why didn't you want your face recognised?
Because I did a film many years ago called *Dead Dreams of Monochrome
Men*, and as a result of that film, people recognised me continuously, and
some still do, twelve years later. What is important to me is to be an observer
and not the observed. The minute you are 'the observed', people no longer
respond to you as they would to [just] anyone, they see you differently. There's
a saying: 'Judge someone by the way they treat someone who'll be of no
importance to them'. I need to see people as they are – not as they would like
to be. I see a lot of well-known people who have become the observed and
have started behaving absurdly. I want to be invisible.
Polly understood that and worked with it?
In all the shots we set up we deliberately tried to camouflage my looks, to
make me unrecognisable. There is something very pretentious about posing
for a photograph which is supposedly about you being important – which I find
fairly questionable. Who decides and judges what (and who) are important in
life? I think my mum has been far more valuable and important to other peo-
ple than I'll ever be. Why is there not a portrait of her up here? Why isn't my
mum up here?

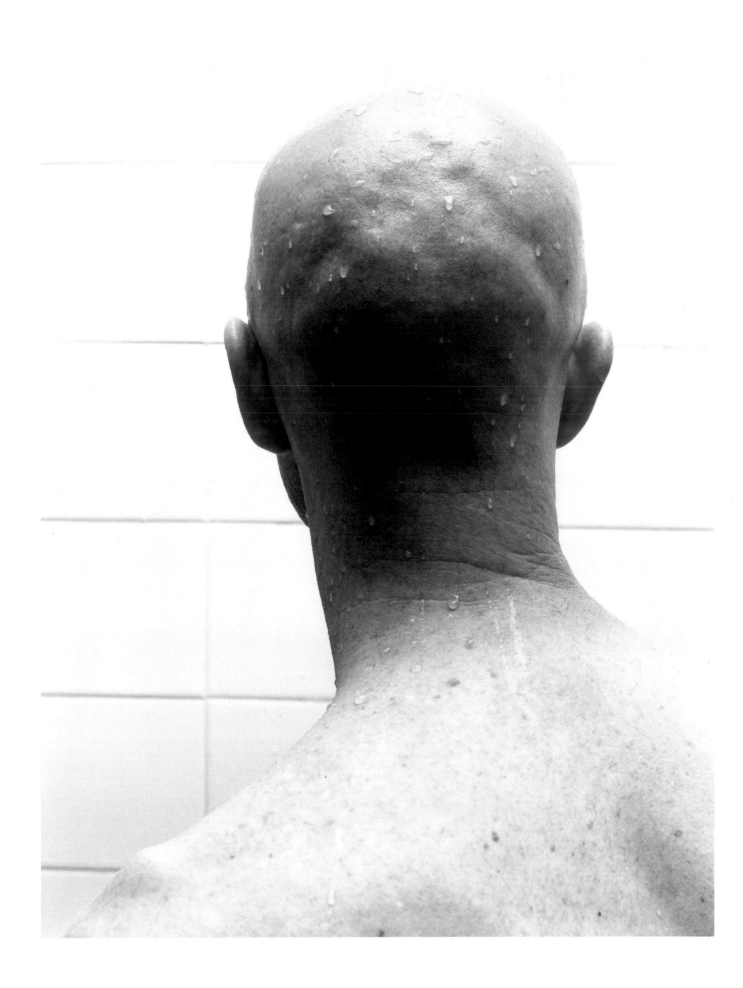

Herb Wharton
Writer, Poet

Born in Cunnamulla, 1930. Herb Wharton left school at the age of
twelve to go droving and completed his first novel *Unbranded* in 1992.
His other publications include *Cattle Camp: Murri Drovers and their
Stories* (1994), *Where Ya Been Mate?* (1996) and *Yumba Days* (1999).
He is a guest speaker at many literary festivals and universities around
the world, Life Member of the Australian Stockman's Hall of Fame,
a Trustee of the Eulo Aboriginal Reserve and an Honorary Ambassador
for Cunnamulla. Wharton is currently working on several novels and
poems and *Bird Kingdom* will be published in 2000.

Speaking from his humpy in Cunnamulla, Queensland

Where did the shoot take place?

It was done in Oxford Street, which is, for me, the busiest street in the world.
There's no traffic lights within two hundred miles of where I am in the bush.
There were probably more people and more buses than you'd see in a cou-
ple of years passed in an hour. [People] milling like cattle, a ceaseless flow.
But they were going both ways. If you had a mob of cattle, you'd probably
want 'em all going the one way. I was dressed like I always am with me Akubra
hat and RM Williams boots. When we were stockmen, RM boots was the only
thing to buy, and they weren't fashion items then. You had to have them or you
wasn't dressed.

How would you identify yourself as an Australian?

I'm an Aborigine from Australia, but no one can speak for all Aboriginal peo-
ple, like no one can speak for all English people. Even before colonisation
there were hundreds of different tribal groups and languages and you've got
to define all this. I see myself as a sort of a messenger who is trying to enter-
tain and enlighten people about the unwritten history of Aboriginal people and
the stories that go back not only to 1788 [white settlement] but going back to
Dreamtime and creation stories. We don't have a cut-off date for our history,
like the millennium. It goes back to the first footprint on earth. I don't have alle-
giances to flags. I don't own the country, I belong to it. That's where my iden-
tity comes from. The land, the earth was my creator. History to me doesn't
come from the sky down, it starts from the earth up.

Has there been a change in Australia?

A lot of Aboriginal leaders would say there's been no change but that's not

true. I know the changes that have happened in my lifetime have been enor-
mous. There's more equality than there was twenty years ago. The housing
and health of Aboriginals in remote areas is still very bad, while others, in the
bureacracy who are looking after them, are doing quite well. So, bureaucrats
do nothing to solve problems, they create them.

What is your view on the referendum?

They wanted a political solution to it, they wanted a republic by the year 2000.
If you get land rights without social justice and economic independence, then
you don't have much. We want to get a solution, but not by a fixed date set by
politicians. One solution is we'd make the Queen an honorary Aborigine, then
she'd be an Australian citizen. We could then be a republic and she'd still be
our head of state. Instead of blaming it all on Captain Cook, it was the
colonists who wrote the constitution and we have ourselves to blame for the
missed educational opportunities. Reconciliation is all about coming to terms
with reality. You can't change the past, but you can help to shape the future for
all the tribes on earth. I still wonder what would have been the state of affairs
today if Adam and Eve had been Aboriginal. For we would have eaten the
bloody snake and not the apple. Paradise was lost on day one.

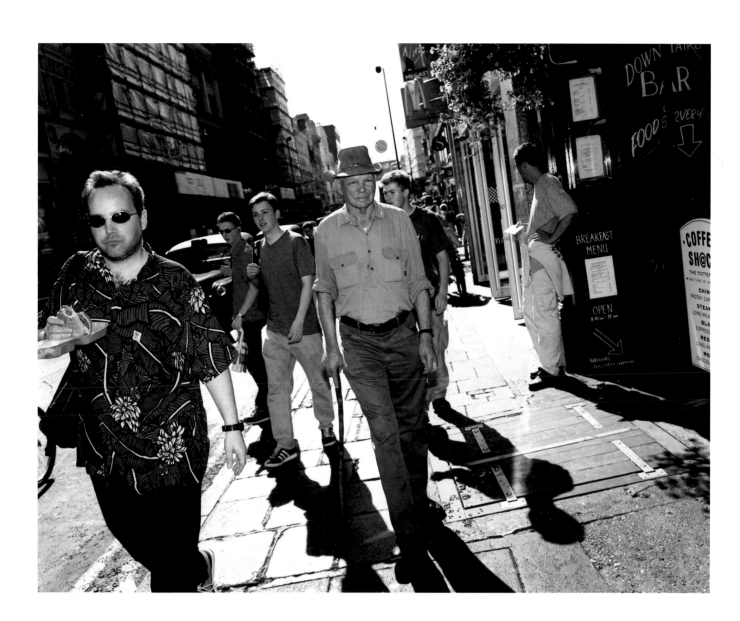

Polly Borland
Photographer

Polly Borland was born in East Melbourne, Victoria, 1959. Before
coming to the UK in 1989, she had established herself as a leading
fashion and portrait photographer, particularly with her work for
Australian *Vogue*. Since then, her reputation has been as an editorial
photographer, specialising in portraits and off-beat reportage.

Her photographs are regularly featured in newspaper supplements
including the *Independent on Sunday Review*, the *Guardian Weekend*,
the *Sunday Times Magazine* and the *Daily* and *Sunday Telegraph*
magazines as well as *Vogue*, *Elle*, *Esquire*, *Arena*, *GQ*, *Dazed and
Confused*, *Marie-Claire*, *Harpers & Queen* in the UK and the *New Yorker*,
Fortune Magazine, *Vanity Fair* and *Details* in the USA. Her photographs
are widely syndicated internationally. She has also shot movie stills
and 'specials' for *Dogs in Space*, directed by Richard Lowenstein, and
Ghosts of the Civil Dead and *To Have and to Hold*, both directed by
her husband John Hillcoat.

Borland's work has been exhibited in both Australia and the UK and
in 1994 she won the prestigious John Kobal Photographic Portrait
Award. The National Portrait Gallery, London recently acquired a
number of her photographs for its collection. In 1999 she took part in
a group exhibition entitled *Glossy: Faces Magazines Now* at the
National Portrait Gallery, Canberra which highlighted the work of six
leading internationally renowned Australian editorial photographers.

Her first book, *The Babies*, a photographic study of adult Babies or
Infantilists, will be published in 2000. A selection of photographs from
this project was exhibited at the South Bank's *Meltdown Festival* in
London, 1999. Her one regret is not having photographed Princess
Diana. Borland hopes to continue exploring 'the dark side of life'.

When I rather boldly asked Terence Pepper, Photography Curator at the
National Portrait Gallery, how I could get a show there, he came up with the
idea of the *Australians* exhibition. Despite my initial reluctance at being seen to
bang the Australian drum, I decided that I wanted to put something back into
Australia. As the project got underway, at times I have felt physically and cre-
atively stretched to the limit. I shot fifty-four portraits in a very tight time frame
in London, Cambridge, New York and Sydney in venues ranging from hotels
to the House of Lords. As we got the list together, I realised how many brilliant
Australians there are and as we did the shoots, I found most of the sitters so
relaxed and down-to-earth, no matter how rich or famous, that it reaffirmed, for
me, the joy of being Australian. The people I photographed have all achieved
remarkable success, although not necessarily reflecting my political or artistic
taste, and many have demonstrated an expatriate spirit of forging ahead to
make their mark internationally.

My main aim, however, was to convey the changed notion of Australian iden-
tity which encompasses a whole new multicultural heritage. Although, this
was hard to reflect as most of the people in this exhibition are of Anglo-
Australian stock – largely due to their blood ties – allowing them easier access
to Britain. Today, the whole notion of identity is no longer about where you
were born or brought up. I feel and sound very Australian, but I do not feel that
I belong there; which can make me feel adrift and homeless. This could have
something to do with the fact that mine is a history based on white colonial-
ism and the attempted physical and cultural annihilation of our indigenous
people. It is a legacy we cannot escape and in this respect I feel that I have
got blood on my hands.

My passion for portraiture stems from my fascination with people; I love
meeting them, I love photographing them, I love finding out about them. The
best result in portraiture is when you get beneath the skin of someone. It is
very psychologically revealing when you penetrate below the surface. I have
never treated photography as pure documentation. I always wanted to have
some hand in what was in front of me. The positioning of people, the back-
grounds, the setting. I wanted to make them more into art pieces than docu-
mentation. There have been people who have questioned my approach, and
that's been stimulating. I haven't always agreed with them, but if a sitter is
going to be uncomfortable with my approach, they are not going to be com-
fortable in the picture. It is not in my interest to stitch someone up, by asking
them to do ridiculous things. I have a basic philosophy in life that you should
never treat people in a way that you would not want to be treated yourself and
I hope that I have imbued the portraits with a sense of the sitters' diginity.

I have really enjoyed this project, and I have laughed a lot with these people
and they have laughed a lot too, so a lot of the photographs are very happy
images, which is unusual for me. Normally they are a lot more serious and
more hard-hitting. For these Australians, I think that is more appropriate.

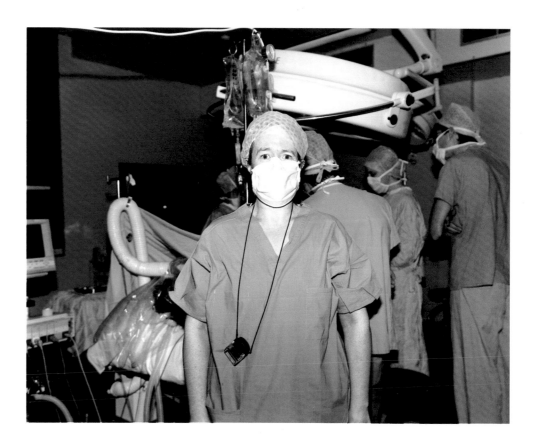

Exhibitions

1983
Diploma of Photography, Prahan College, Melbourne;
including direction of one short film and work on others

1984
Solo exhibition, George Paton Gallery, Melbourne

1985
Through the Glass, Darkly, Fashion Design Council,
Victorian Ministry of the Arts Gallery, Melbourne

1986
Image Perfect, curator Sandy Edwards,
Australian Centre for Photography, Sydney

1987
Ormond College Welcomes New Art, curator Tony Clark,
Ormond College, University of Melbourne
Survey of Contemporary Australian Photography,
curators Anna Weiss and Luba Bilu, Linden Gallery, Melbourne

1988
Bone, curator Susan Rankine,
Gertrude Street Gallery, Melbourne

1990
South Bank Photographic Show, Royal Festival Hall, London

1993
John Kobal Photographic Portrait Award, Zelda Cheatle Gallery
and Angela Flowers Gallery, London

1994
Winner: Best Portrait, *John Kobal Photographic Portrait Award*,
National Portrait Gallery, London, Royal Photographic Society, Bath and
Scottish National Portrait Gallery, Edinburgh

1999
Young British Artists, National Portrait Gallery, London
Glossy: Faces Magazines Now, National Portrait Gallery, Canberra
Meltdown, curator Nick Cave, South Bank, London

2000
Psycho: Art and Anatomy, curator Danny Moynihan,
Anne Faggionato Gallery, London
Polly Borland: Australians, curator Terence Pepper,
National Portrait Gallery, London

Acknowledgements

I would like to thank all my portrait sitters who generously gave their valuable time and trust to me. Special thanks to Nick Cave who is a dear friend and helper to the cause and has written something wonderful and incisive about me; Peter Conrad for writing a brilliant catalogue essay; Virginia Ginnane for tirelessly interviewing everyone; David Wayman for being such a kind and talented man; Peter Miles and Miles Murray Sorrell (Fuel) for a great catalogue design which allows the photos to breathe in a limited space; Fay Leith for doing beautiful make-up and hair; Paul, Dennis, Edwin, Kevin and Robin at Tapestry for their excellent work under enormous pressure.

I would also like to acknowledge the Australian High Commission: Philip Flood, Hugh Borrowman and Tony Brett Young for their help and support throughout the project; Andrew Sayers, Magda Keaney and David Andre at the National Portrait Gallery, Canberra for their continuing support of me and my work; Liz Jobey and Mark Holborn for their encouragement and help with my career in England; Victoria Lukens for employing me for all these years; to the following for their support:Tony Clark, Martin Grant, Cressida Connolly, Charles Hudson, Celia Johnstone, Marsha Schofield, Richard O'Flynn and Evelyn Smith.

I would like to thank the following people at the National Portrait Gallery, London for their support throughout this project: Pim Baxter, Hazel Sutherland, Emma Marlow and the PR and Development department; Terence Pepper whose idea it was for me to photograph the Australians and for his encouragement throughout this project and my career; Jacky Colliss Harvey for taking the risk of publishing the catalogue and Anjali Bulley for editing the book and putting up with everyone's egos!

To Simon Crocker, my friend and agent, who has to put up with my moods and who oversaw the logistics of every shoot along with his assistant Tori Nelson putting up with Simon who was putting up with me – she organised everything brilliantly. Another long-suffering person is my assistant Jenny Lewis who had to put up with everything from my exhaustion to every tricky situation we found ourselves in, and to Graham Carlow, my other assistant, who didn't have to put up with as much because he wasn't there so much.

Above all, special thanks go to my husband John Hillcoat for encouraging me and propping me up whenever I needed it, for his tireless interest in my projects and his keen vision for the best pictures.

Polly Borland

Thanks also to David Wayman for photographic retouching; Annette Falconer for initial research; Photograph of Polly Borland by her assistant Jenny Lewis; St Martin's Lane Hotel for the Cate Blanchett location; Fay Leith for hair (using Charles Worthington Results) and and make-up (using Lancôme) for Kylie Minogue, Elizabeth Murdoch, Leanne Benjamin, Samantha Bond, Cate Blanchett and Natalie Imbruglia (make-up only); Elle Macpherson's hair and make-up by Linda Johansson; Natalie Imbruglia's hair by Yiotis Panayiotou at Vidal Sassoon.